INNER VISIONS
THE ART OF RON WALOTSKY

Inner Visions

He paints from his soul,
Unique inner visions.
A master of colour,
Line, form and precision

Other world landscapes
With aliens abound,
Hearing the canvas,
Watching the sound

The dabs of paint gather,
Fluorescent or pale,
An eye in the sky,
A pirate ship's sail

Mysterious whispers
Send shadows beyond.
Softening and blending,
A visual bond

Chilled metal rockets,
Suspended in space.
Aztec graffiti
Surrounds a masked face

Liquid shapes puddle
On hard-edged design,
A gash of pure crimson,
Suspended by line

A mystical fortress,
One dazzling sphinx,
Realms of red dragons,
An amber-eyed lynx

He summons the spirit
That deepens the trance.
His brush the baton
Leading destiny's dance

Jill Bauman

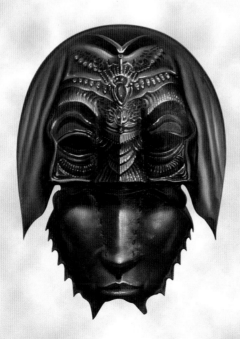

Facing page:
Rossini Overtures
album cover for RCA Red Seal, 1979
45 x 45cm (18 x 18in), acrylic on board

INNER VISIONS
THE ART OF RON WALOTSKY

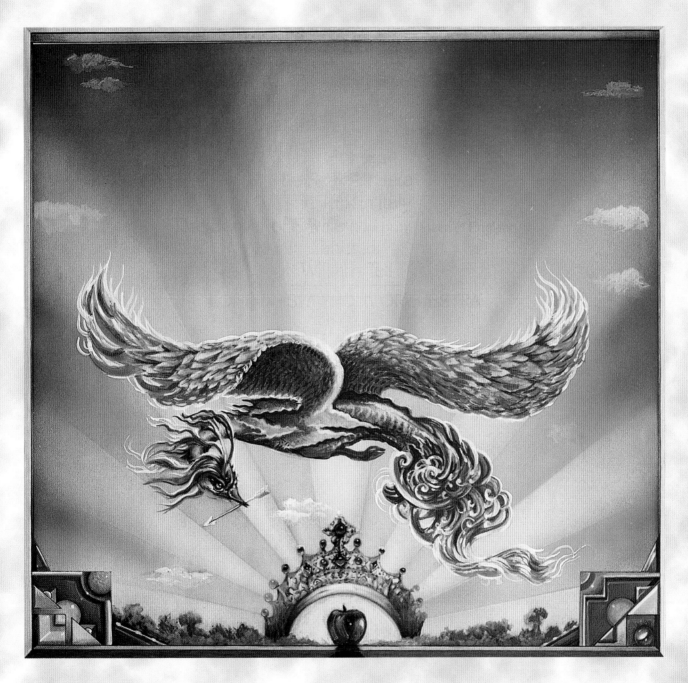

PaperTiger

This book is dedicated to Rebecca, Sylvia and Gail,
without whose support and backing
this wouldn't have been possible.

ACKNOWLEDGEMENTS
*Jim Frenkel and Joe Miller worked extensively with me on this
book in one of its earlier incarnations, and I'm eternally grateful to
them for that and much else. Paul Barnett (a.k.a. John Grant)
put this final incarnation together and became a good friend
in the process: thanks, Paul.
Many thanks also, for their time, energy and goodwill, to all
the people who contributed written pieces to this book.*
Ron Walotsky

First published in Great Britain in 2000
by Paper Tiger
an imprint of Collins & Brown Limited
London House, Great Eastern Wharf, Parkgate Road
London SW11 4NQ
www.papertiger.co.uk

Distributed in the United States and Canada by Sterling Publishing Co,
387 Park Avenue South, New York, NY 10016, USA

1 3 5 7 9 8 6 4 2

British Library Cataloguing-in-Publication Data:
A catalogue record for this book
is available from the British Library.

ISBN 1 85585 774 X

Designer: Malcolm Couch

Reproduction by Global Colour, Malaysia
Printed and bound in Singapore

The Passionate Weirdness of Ron Walotsky

When you walk through the front door into Ron Walotsky's house in Florida – a two-storey manse on a creek that leads to the Intracoastal Waterway, a mile from the ocean – you immediately notice colour and form in zany celebration. Ron has his paintings hanging everywhere, ranging from corporate art to wall-sized abstracts to the excellent, exuberant science fiction and fantasy that grace these pages.

I'll put my own prejudices on the table and tell you about my favourite pieces. I've been most drawn to, hypnotized by, the abstract compositions – dramatic in-your-face illusions that are modern avatars of classic *trompe l'oeil* technique: arm-sized snakes of paint seeming to float a foot off the canvas; a thousand pebbles in a stream, in hugely impossible close-up; carefully drafted geometric fantasies.

When Ron's agent puts on gallery shows, she displays either his abstract work or his science fiction, but not both. People who go to galleries get confused. Consumers and critics of art think of commercial art

as one thing and "serious" art as another. But it's all serious, and it's all play, and it's all done by the same mind and hands, just working under different sets of constraints.

Good hands and an interesting mind. Ron has a solid academic background and is totally serious about his work, but doesn't look or act like an *artiste* – do any real artists? – but rather like a regular guy from Brooklyn, eager to show you his little beach town and kick back for a brew in a ramshackle bar overlooking the surf. How he has *time* to be a regular guy is beyond me! I've known lots of artists, in and out of science fiction, and I know the only way to make a living outside of the academy is to be prolific.

"Prolific" doesn't begin to describe Walotsky's output. You can spend hours looking at the paintings (and pictures of the paintings) that have been his life for the past 30 years. Mostly science fiction and fantasy, because those are his central passion, but alongside the abstract paintings there are dozens in other genres: Western, mystery, and mainstream book covers; psychedelic poster art from the 1970s; luscious nudes for magazines like *Penthouse*. Album jackets for rock groups and musclebound heroes for *Heavy Metal*. Bits of sculpture and oddities that defy description. In one corner of the studio, examples of an ongoing project, "Ancient Warriors from Lost Civilizations": a series of masks painted on the shells of horseshoe crabs. Neighbourhood kids collect the shells from the beach and bring them to Ron for a dollar apiece.

When I last visited that cluttered studio, there were three of these masks drying, their tails weirdly stuck in a Styrofoam block so the masks were upright and staring. To an old Florida beachcomber who's seen thousands of horseshoe crabs, there's an unsettling cognitive dissonance: it's a crab, it's a face; it's a crab, it's a face . . . Ron was working on two other paintings at the time, his back to the masks, which didn't look happy. If I were him I would have turned their faces to the wall.

Ron usually has several projects in various stages of completion, but like all commercial artists he often has to drop everything and race a deadline. I was looking forward to spending some time with him in

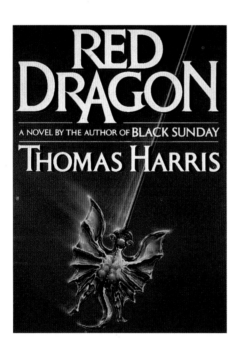

Above:
Red Dragon
cover for the novel by Thomas Harris, Putnam, 1981
40 x 50cm (15 x 20in), acrylic on board

Putnam's art director, Lynn Holland, gave me the manuscript of Harris's novel. As a basic image I used William Blake's painting The Red Dragon. In the novel Hannibal Lecter steals the original painting from a museum and eats it to give himself the Red Dragon's powers. In fact, the original was still hanging in the Brooklyn Museum of Art, and so I went there to get a proper look at it. I wanted my illustration to be pretty simple, so I settled on a silver image of the Red Dragon, sort of like a swinging pendulum axe.

Facing page:
Tightrope
cover for *Heavy Metal*, October 1978
75 x 100cm (30 x 40in), acrylic on canvas

This was one of the paintings I worked on for myself while I was living in upstate New York. The central concept that came to me was the impossibility of going down the side of one of the Andes on a tightrope; the mask on the woman's head came later. This was a very allegorical painting for me – and it was one of those that I had to do to get it out of my system: the image wouldn't leave my mind until I created the painting to go with it. Later on Heavy Metal used it as a cover illustration.

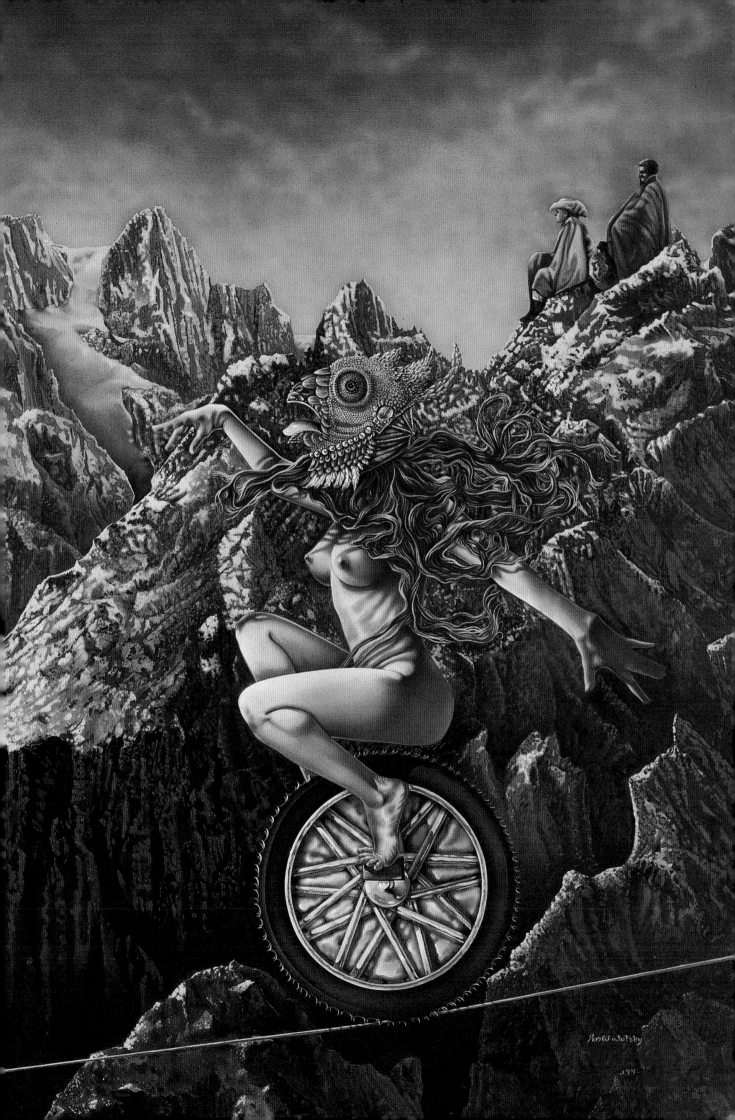

Fort Lauderdale last year, where he was scheduled to be honoured by the International Association for the Fantastic in the Arts, but the phone rang and an editor asked whether he could do 12 paintings for a children's book in 20 days. Honours are nice, but work is what you do, so while the rest of us were down there basking under a thin layer of sunblock, Ron was cranking from dawn to midnight, loving it, chain smoking and sucking coffee while he worked with his characteristic meticulousness. I haven't asked him, but I suspect he FedExed the paintings, took a little time off for a sandwich, and then went back to what he had been doing when the phone rang three weeks before.

Love of the abstract and the downright weird is evident in many of his paintings. It's obvious in the background of the space-suited figure from the poster for the Third Eye Poster Company (page 19), Mondrian blocks falling out of a fractal sky – and the reflection in his helmet shows that what's in front of him is as strange as what's behind him. The bulbous organic alien spaceship illustrating Ben Bova's *Prometheans* (page 81) looks like a Gaudí dream interpreted through an alien sensibility. Even the more conventional hardware in the covers for Marion Zimmer Bradley's *Darkover Landfall* (page 108) and Poul Anderson's *Tau Zero* (pages 84–85) have an eerie solid sensuality to them.

Those three spaceships well display Ron's versatile imagination. Most science fiction artists have a "canonical" spaceship, which they use over and over, ringing in changes. These three look like the work of three independent artists. The *New York Times*'s art critic, Hilton Kramer, recognized this range and diversity when he noted that:

"Each of his pictures is an entirely individual conception. What unites them into a consistent stylistic statement is the character of their colour and the means used to realize it . . . a very romantic, slightly unearthly, slightly psychedelic colour achieved through painstaking gradations of light. There is at once an almost electric quality to the colour in Walotsky's paintings, and a dreamlike quality to the atmosphere they evoke."

Words like "romantic" and "dreamlike" don't come immediately to mind when you meet this energetic wisecracking Brooklyn-ite in his jeans and flannel, as out of place in a sleepy Florida town as an alligator in the Holland Tunnel. But when he picks up a brush to adjust a line or a tone, a change comes over him, like auto-hypnosis, a direct current between the painting and the painter.

His connection to the work is absolute, and beautiful.

Joe Haldeman

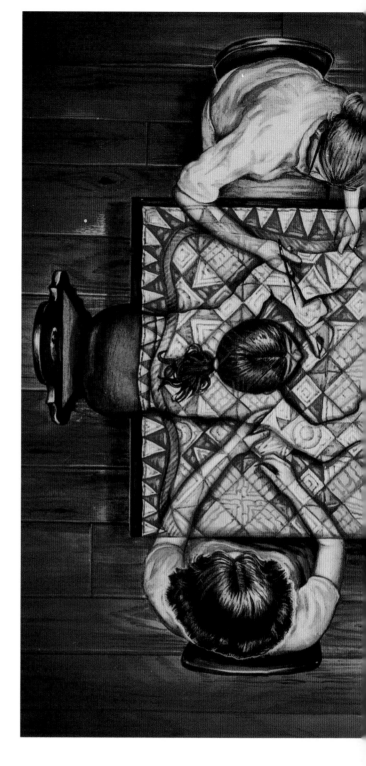

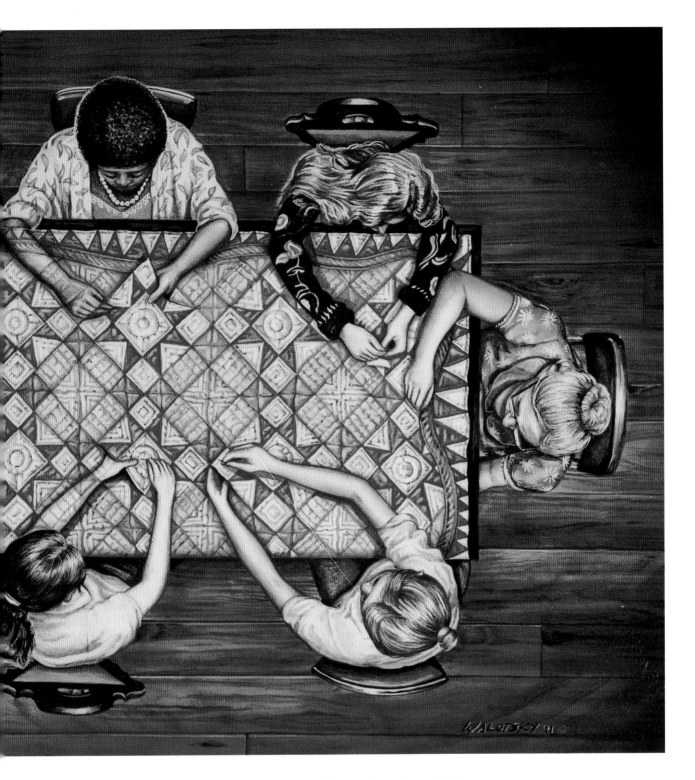

How to Make an American Quilt
advertisement illustration for a novel by Whitney Otto,
Literary Guild, 1991
40 x 50cm (15 x 20in), watercolour

*The novel is about eight women who, as they sit around the table making a quilt together, talk about
their life stories, so that these become intertwined with the story of the quilt.
I had the idea of making the women actually part of the quilt: as you go around the table, so
the women move in and out of the quilt. I thought this not-strictly literal reading of the novel gave
a nice surreal flavour to the painting.*

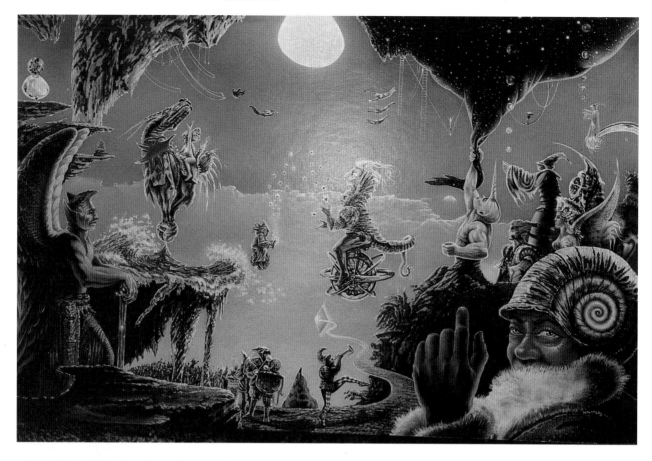

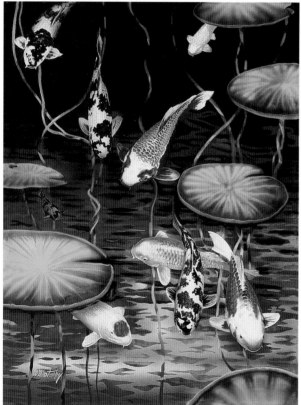

Above:

Alien Circus
title page for *Heavy Metal*, February 1980
45 x 60cm (18 x 24in), acrylic on board

When Heavy Metal asked me to do a circus piece for their title page I decided to make it a space circus. This allowed me to have the acrobats and other performers do some very strange things, like pull the sky down to show the depths of space behind it. Very much a magical alien extravaganza. One of the performers is asking you to come in and view the sights.

Left:

Koi Fish
private commission, 1997
50 x 70cm (20 x 28in), acrylic on paper

The subject of koi fish was not exactly at the forefront of my general knowledge when I was asked to do a painting about them. So I read a couple of books and discovered that the breeding and showing of these exotic fish, originally a traditional Japanese activity, is a hobby with a huge following: there are koi clubs throughout the United States and in many other countries as well. Each of the fish in the painting is a different type of koi, as people in the know will recognize.

Facing page:

Eclipses
brochure cover for Data General Corporation, 1981
75 x 100cm (30 x 40in), acrylic on masonite

When Data General asked me to do the cover illustration for the brochure for their new computer chip, the Eclipse, I originally thought of an abstract piece. However, they wanted a landscape. At the time I was living in a small town in upstate New York. The view from my front porch was of a deserted golf course that stretched away into a valley; you could see bits of about three mountain ranges. I once saw the Northern Lights from here, and this gave me the idea of having the chips moving through the sky. I put an undercoating of burnt sienna over a gesso ground, pencil-sketched the image I wanted, then started to layer in the colour, working from dark to light. The last thing I did was to pop in the highlights. I wanted to capture a combination of hi-tech and landscape in a single unifying theme.

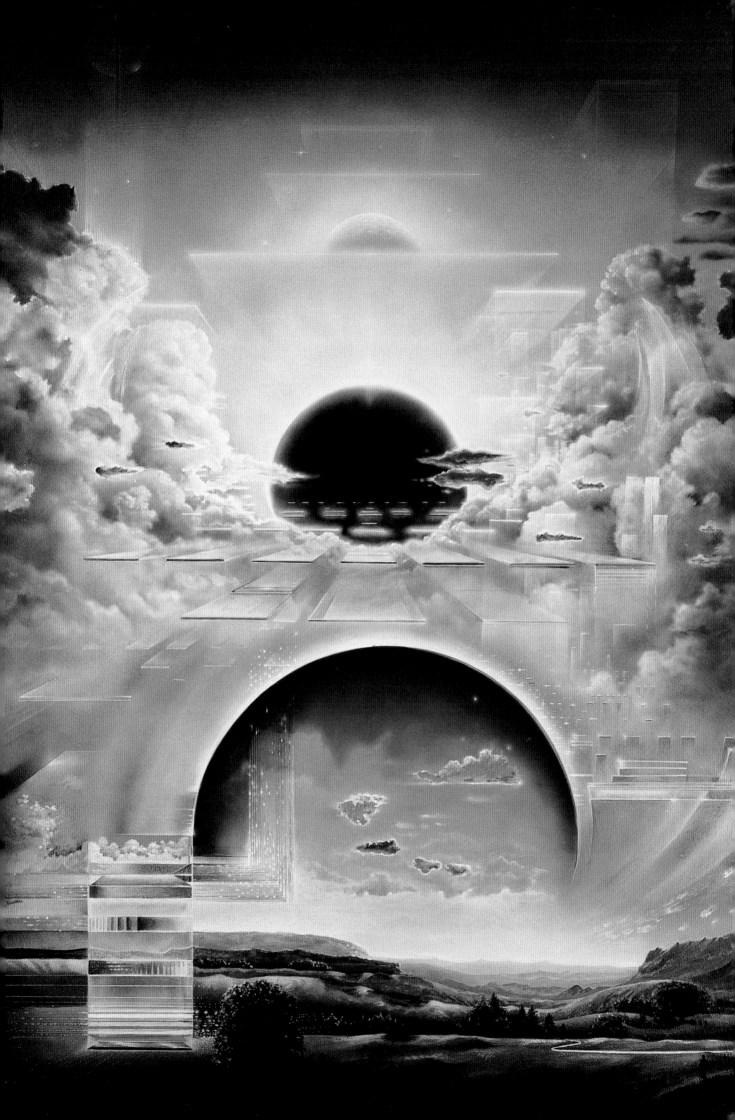

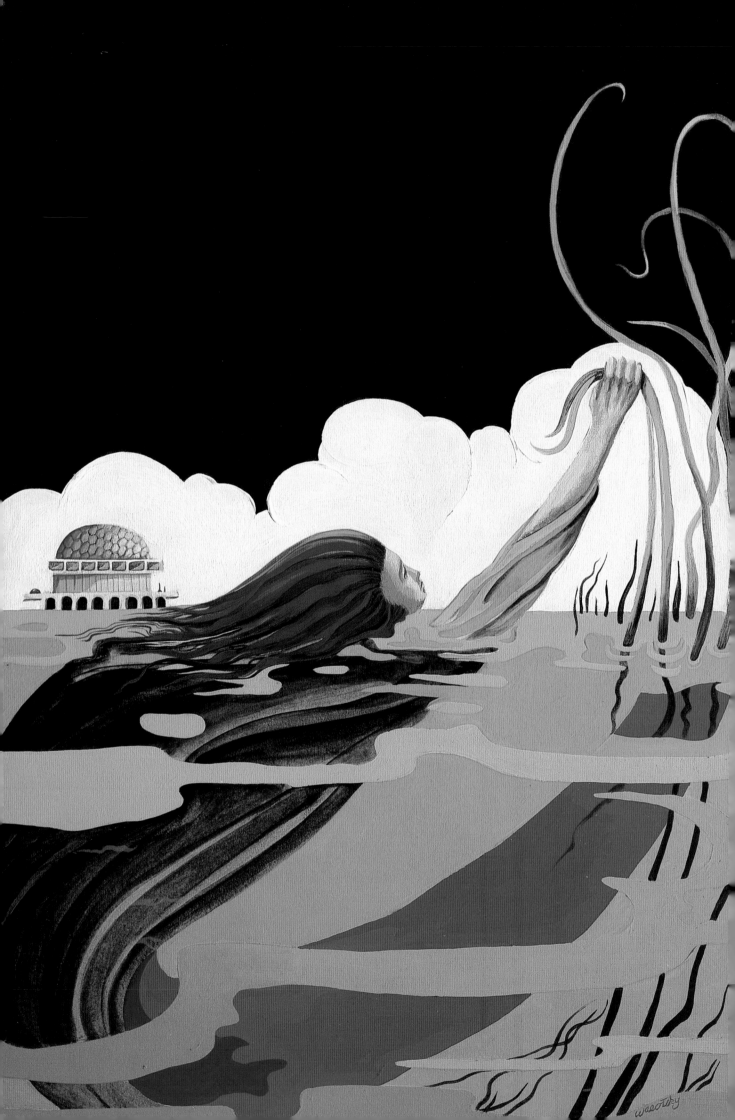

IN THE BEGINNING WAS THE COMMISSION . . .

After I graduated from the School of Visual Arts, I started my professional career by going to the different publishing houses in New York looking for work. My first cover commission was from The Magazine of Fantasy & Science Fiction in 1967: the cover story I was asked to illustrate was "Planetoid Idiot" by Phyllis Gotlieb (facing page). Now I think about it, that was a strange title with which to start one's career!

After I'd completed the picture and handed it in, I kept going to bookstores, flicking nervously through the racks, desperate to see my cover in print. To me, painting a cover for F&SF was the most thrilling thing I had ever done. When finally I saw it on a newsstand I wanted to tell everybody that this was my work – I even told the guy in the newsstand.

About the same time, I was doing psychedelic posters for a company called Dream Merchants – Day-Glo silkscreens of Jimi Hendrix, Jim Morrison, Joe Cocker and so on. I've never been happy with doing only two things at once, so I was also working on my own paintings. These were mystical images: I was into Eastern philosophy, like many of us were in the 1960s, and I felt a need to express my own vision rather than just always interpret other people's – and I continue to this day to paint for myself on this basis.

Facing page:
The Planetoid Idiot
cover for The Magazine of Fantasy & Science Fiction, May 1967,
illustrating the story by Phyllis Gotlieb
40 x 50cm (15 x 20in), acrylic on board

This was the first cover I ever did for F&SF.
My relationship with that magazine has lasted far longer than anyone could have expected.

POSTER ART

I did a series of Day-Glo posters and by current standards the technology in use was rudimentary. I created each poster using four screens I had hand-cut, one for each of the primary colours – yellow, red, blue and black. The four secondary colours – green, orange, purple and brown – could be achieved by overlaying one primary colour on another. That meant I had a total of only eight colours with which to render the image. But I didn't feel oppressed in any way by the restrictions; quite the reverse, I found the challenge of producing decent images this way very exciting. After that, in the early 1970s, I worked on a set of surreal posters for the Third Eye Poster Company; there are three of them here. Some derived from drawings I'd done when I'd been in Los Angeles in the late1960s – Future Past (facing page) and Birth (page16). Everything out there was a bit bizarre at the time, to put it mildly, and so these drawings came in pretty useful when it came to generating surreal images.

Facing page:
Future Past
poster for the Third Eye Poster Company, 1971
50 x 75cm (20 x 30in), acrylic and enamel on board

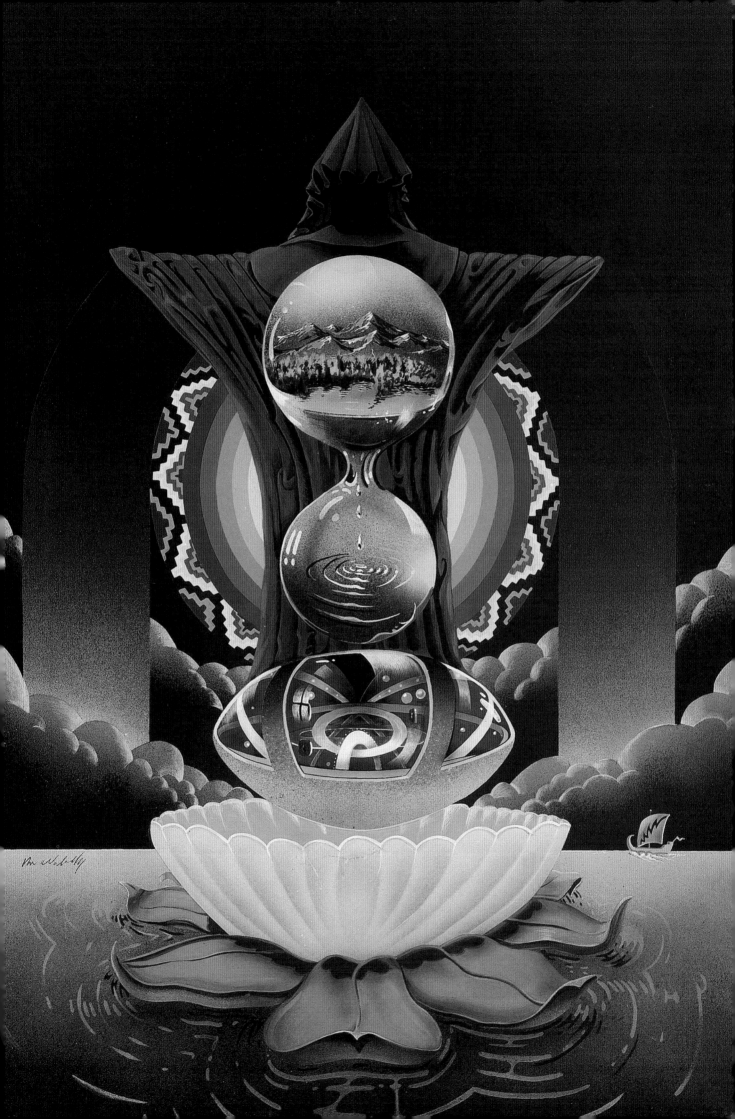

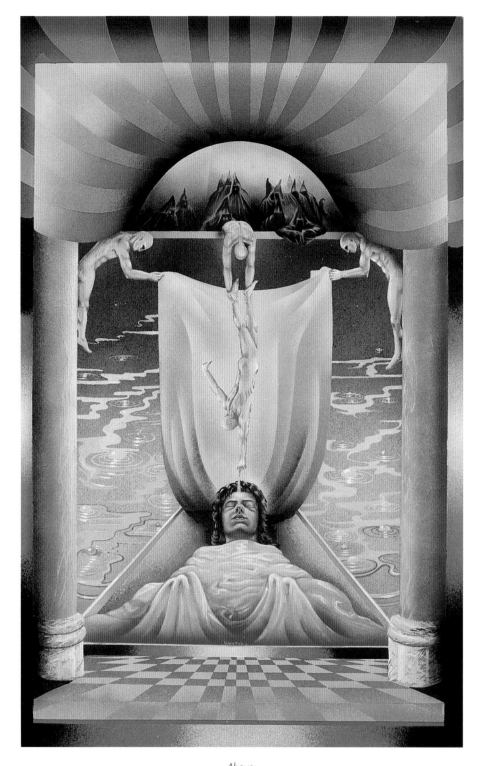

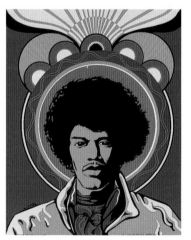

Above:
Birth
poster for the Third Eye Poster Company, 1971
50 x 75cm (20 x 30in), acrylic and enamel on board

Top right:
Season of the Witch
poster for Dream Merchants, 1968
92 x 60cm (36 x 24in), seriograph

Centre right:
Jim Morrison
poster for Dream Merchants, 1968
92 x 60cm (36 x 24in), seriograph

Above:
Jimi Hendrix
poster for Dream Merchants, 1968
92 x 60cm (36 x 24in), seriograph

That Sense of Wonder

My whole life is defined by science fiction. I started reading it in 1957 when I was 11 years old and have never stopped. Within two years I amassed a collection of several hundred used paperbacks and old sf magazines, mostly bought in used bookstores in the Newark (NJ) and New York City area at the bargain price of 10 cents each or three for a quarter. This was just the beginning of a lifelong passion.

All through high school, then college and graduate school I continued to collect. Although I earned two degrees in mathematics, I knew deep down inside myself that my future lay in science fiction. Hard work and a lot of luck helped me establish Weinberg Books, Inc., the largest mail-order new sf book business in the world, which my wife and I ran very successfully for more than 25 years. During that entire period I also bought and sold rare science fiction books, paperbacks, magazines and original art. Especially original art.

Science fiction is different from most genre fields in that not only rare books and out-of-print classics are available for sale from dealers, but artwork is as well. Most science fiction conventions have art shows where artists can display their paintings and offer them for sale to fans. Over the decades, many exceptional pieces of art have been bought by dedicated collectors and thus preserved as a part of science fiction history. There's a thriving market for both old and new science fiction originals. And usually the prices are incredibly reasonable, especially when compared to the cost even of numbered lithographs by non-science fiction, but more famous, artists.

I began seriously collecting original science fiction artwork a little more than 27 years ago. Naturally, my first purchases tended to be works by the artists I grew up with as a teenager reading sf – talented cover illustrators for 1950s and 1960s paperbacks, including Ed Emshwiller, Kelly Freas and Ed Valigursky. As my collection grew, so did my interests. I focused on the artists who were famous during the first Golden Age of Science Fiction, 1939–1943. I eagerly bought work by Virgil Finlay, Edd Cartier and Hannes Bok, the three men whose work I felt helped define science fiction illustration. From time to time I bought work by a modern artist, but my collection remained primarily historical. In a way, it served as a pictorial history of the science fiction field from its earliest beginnings to its acceptance into mainstream fiction in the late 1960s and 1970s.

At present my collection numbers somewhat over 500 pieces of original science fiction art. Less than 10 per cent of that array is made up of paintings dating after 1970. Needless to say, it takes an exceptional artist to have work included in that select group. Heading that extremely small list is Ron Walotsky.

Why do I think so highly of Ron's work? I could list many reasons – his brilliant sense of and use of colour; his flair for the dramatic; the depth of perception in each of his paintings and an obsessive attention to detail that creates an atmosphere of almost photographic realism. But, most of all, I'm forced to fall back on the central reason I've always loved science fiction artwork. Although Ron's art wonderfully illustrates the story for which it's been painted, the artwork also stands independently as a work of sheer beauty and imagination. As old-time science fiction fans put it best, Ron's paintings are filled with the "Sense of Wonder".

Look at the painting for *Ancient Echoes* (page 31). (I do every day – it's hanging in my dining room!) While the book is a fine one, the painting on its own – with its elaborate floating mask, ancient ruins and decorated columns – in effect defines the very word "fantasy". Or stare for a moment at his piece for *The Unknown Region* (page 36). That moment will turn into minutes and, if you're lucky enough to see the original, perhaps hours. There's art in this book to inspire countless tales of fantasy and science fiction. Ron takes a scene and makes it his own. His work resonates with the magic that is science fiction, that is fantasy. It truly is filled with that Sense of Wonder.

Finlay, Bok and Cartier weren't the only artists who worked during the first Golden Age of Science Fiction, but they're remembered because they were the very best. There are many fine artists working in the science fiction and fantasy field today. Unfortunately, over the years, most of them will be forgotten. But not Ron Walotsky. For, without question, his work ranks right along with the finest of Finlay, Bok and Cartier. He's definitely one of the very, very best.

Robert Weinberg

Page 18:
Cycle
poster for Dream Merchants, 1969
92 x 60cm (36 x 24in), seriograph

Page 19:
Spaceman
poster for the Third Eye Poster Company, 1971
40 x 50cm (15 x 20in), acrylic on board

This was one of the first times I tried to combine sf art with my abstract style. At the time my abstracts concentrated on thin bands of colour containing very subtle gradations; as reference for the representational part of this painting I used an image from Life Magazine showing an astronaut walking on the Moon. The reflection in his visor was my own idea: he's looking at an alien outpost of some kind.

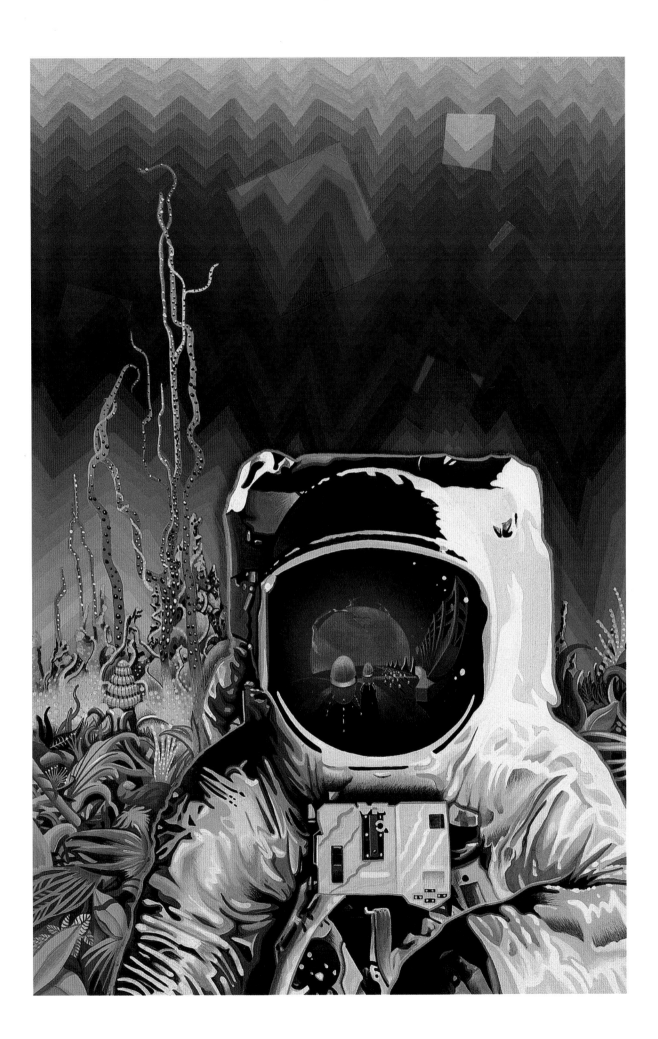

2

COVERS FOR *THE MAGAZINE OF FANTASY & SCIENCE FICTION*

When I first started doing covers for F&SF, I didn't think it would still be going on 33 years and 55 covers later!

Ed Ferman is the publisher of F&SF. When he sends me a manuscript he never tells me what he thinks the cover based on it should look like – a situation I love. Instead, he leaves it to me to get the feeling of the story. Afterwards, I don't think he's ever once said "Change this" or "Change that". Also, when I was first starting out, he would on occasion send me the cheque even before the painting was completed. It's not something any other publisher would ever think of doing.

All of this has, naturally, bred in me a sense of loyalty to F&SF. Whenever Ed needs something from me in a hurry, I drop everything else I might be working on and do Ed's bit of work immediately.

Facing page:
Bridges
cover for the 43rd anniversary issue of *The Magazine of Fantasy & Science Fiction*, October 1992, illustrating the story by Charles de Lint
40 x 50cm (15 x 20in), acrylic on board

I like this type of story. At its heart is an interestingly surreal image representing the way you have to make personal decisions about the directions your life will take. I tried to capture the emotional insecurity of the main female character. This painting was nominated for a Hugo Award.

Once Upon a Clueless Youth

I guess I first met Ron Walotsky in 1966, which must have been very early in his professional career – very early in his life, in fact. He was barely out of his teens, a long-haired, clueless youth with a ragged portfolio mostly, as I recall, of weird psychedelic designs. Fortunately for both of us, I was equally clueless about art and needed a cover quickly for the next issue of *The Magazine of Fantasy & Science Fiction*.

Surprise! He turned in a polished and stunning piece of work, based on Phyllis Gotlieb's "Planetoid Idiot". That was the beginning of a long and productive run. And what an exciting and varied body of work it is. To name just a few favourites: the giant rat in the jungle of Sumatra for Sterling Lanier's "A Father's Tale"; the three-dimensional chess game for Barry Malzberg's "Closed Sicilian"; the grim corpse in space for Michael Shea's "The Autopsy"; the lovely award-winning piece for Carolyn Gilman's "Candle in a Bottle"; and, perhaps my favourite of all, the wonderful San Francisco scene for Fritz Leiber's "The Pale Brown Thing".

So that clueless youth has turned into *F&SF*'s senior illustrator, with over 40 covers for the magazine – more than any other artist. And the good news is that he still shows no signs of repeating himself or slowing down.

Ed Ferman

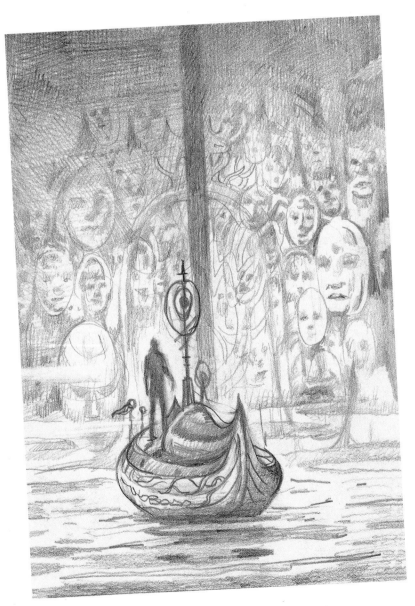

Facing page:
Gate of Faces
cover for *The Magazine of Fantasy & Science Fiction*, April 1991, illustrating the story by Ray Aldridge
40 x 50cm (15 x 20in), acrylic on board

In this interesting story a man was given the choice – symbolized by a gate through which he must pass through or not – between death or immortality. The gate in this illustration has surrounding it all the people, including androids, who have featured in his life. I think I caught the feeling of the story, and the painting is a personal favourite of mine.

Left:
Preliminary sketch for *Gate of Faces*, pencil

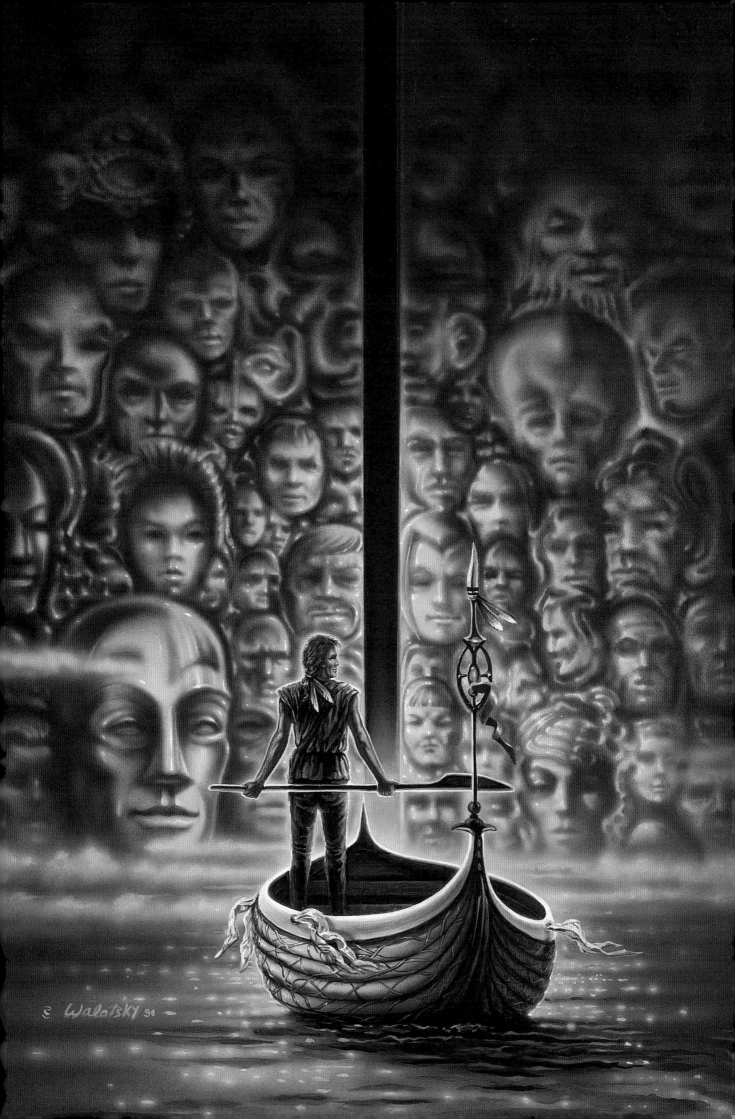

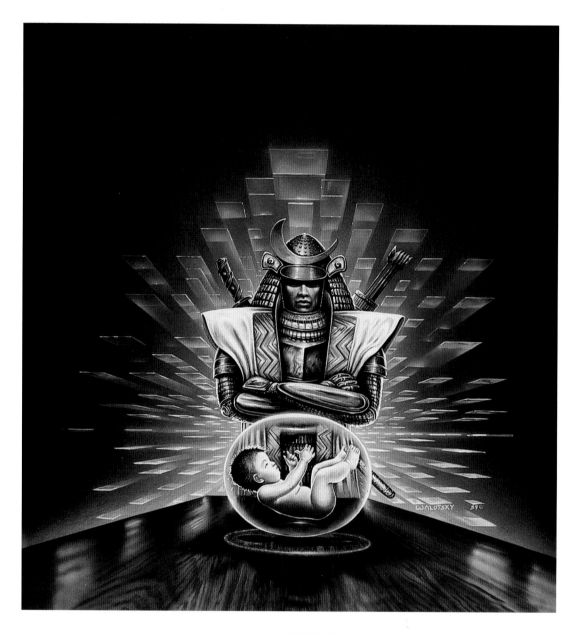

Above:

Doctor Pak's Preschool

cover for *The Magazine of Fantasy & Science Fiction*,
July 1990, illustrating the story by David Brin
50 x 50cm (20 x 20in), acrylic on board

*Brin's story was about samurai and genetically engineered babies.
I stole the image of the samurai from one of my favourite movies,
Ran (1985) by Akira Kurosawa, which is based on Shakespeare's
King Lear. I thought the juxtaposition of the samurai and the baby,
almost diametrically opposed to each other, would make an
incredibly striking composition.*

Right:

The Spine Divers

cover for *The Magazine of Fantasy & Science Fiction*, June 1995,
illustrating the story by Ray Aldridge
40 x 50cm (15 x 20in), acrylic on board

Facing page:

The Cold Cage

cover for *The Magazine of Fantasy & Science Fiction*, February 1990,
illustrating the story by Ray Aldridge
40 x 50cm (15 x 20in), acrylic on board

*The basic idea of this story about a warden on a prison asteroid was
that he was as much a prisoner as the inmates, and I tried to convey
this sense of confinement. The best part of doing this picture was the
texture, especially the pitted and scarred surface of the wall on
either side of the image of the warden.*

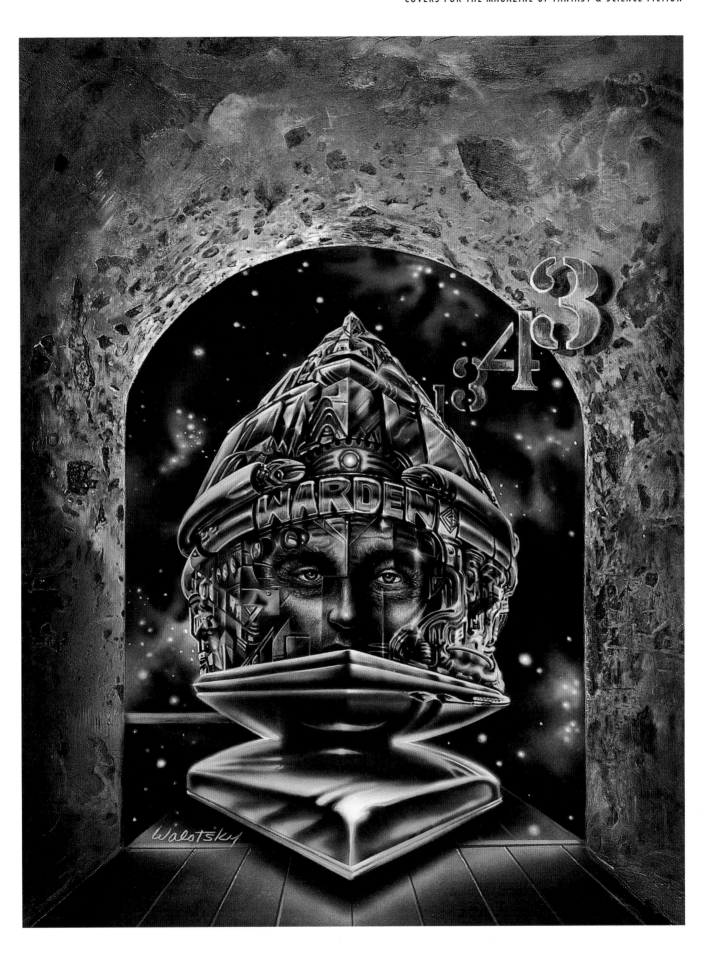

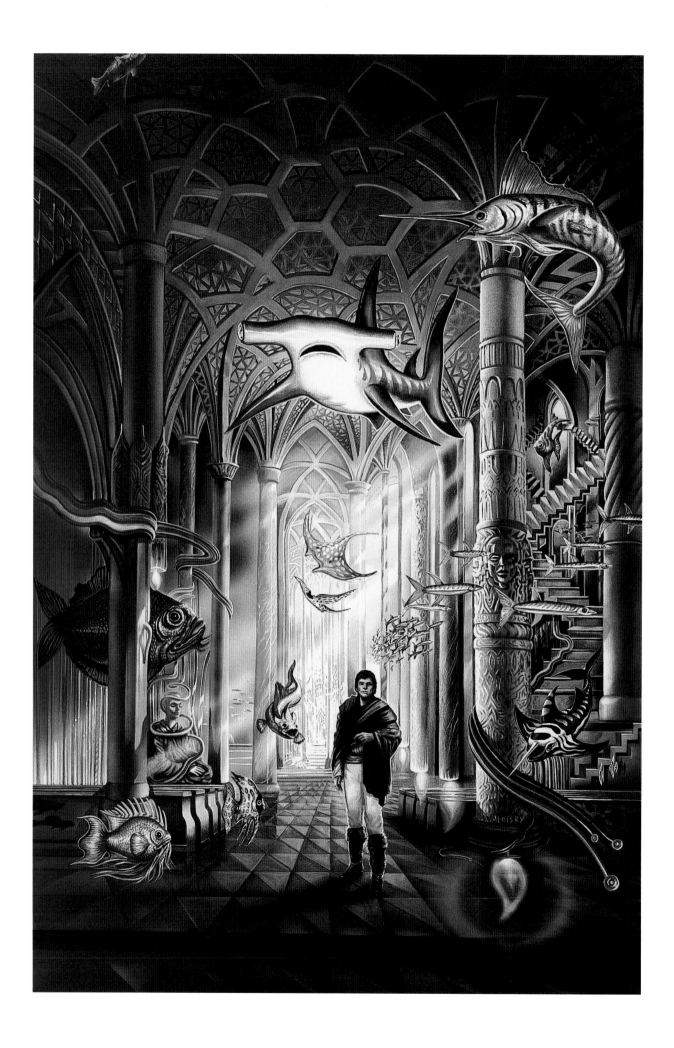

Not Our Daily Drudgery

In any field, most especially in the creative arts, you tend to find two types: the nice people, and the talented ones. When you find both traits in one person, treasure that individual.

Hence I'm delighted to discuss Ron Walotsky.

My first encounter with Ron was not, in fact, in 1986 when I worked for Bluejay Books. That summer morning was the first time we were actually introduced. Ron dropped in to deliver a painting (the cover for Barry Longyear's *Sea of Glass*, I think). Jim Frenkel hadn't yet arrived – the time was 9:30 or 10:00am – so Ron just took a seat in the corner of the crowded office and fell asleep.

But no, I must go back to 1985 if I'm to be honest.

In my freshman year of college, I went with the science fiction club members to a convention in Boston – it was only my first or second convention, and the dealer's room looked to me like the proverbial candy shop looks to the proverbial kid. At one point I was pawing some prints for the covers of Zelazny's "Amber" novels (Zelazny was to me what Edgar Rice Burroughs was to previous generations of adolescents: the stuff of pure heroic fantasy) and a woman said excitedly, "Are you going to buy that one?"

"Uh, yeah, I think so."

"Well, my boyfriend painted that – here, let me get him to sign it for you." Whereupon she yanked Ron from his browsing on another table and he cut the shrinkwrap and signed the print in gold pen.

I was struck even then by how unassuming he was, and in the years since I've never once seen Ron put on the airs so common to artists of his calibre.

By now I've had the pleasure of working with Ron on roughly a dozen covers – *Panda Ray, The Ragged World, Temporary Agency, Fires of the Past, Griffin's Egg, The 37th Mandala, Essential Saltes*, and maybe I've forgotten a few. Ron is always reliable in three different ways:

1) The art always has a dreamy, somewhat mystical feel to it, with a lovely texture of detail.

2) The palette will be rich. Ron uses colours and shades that come from dreams and sunsets. There is nothing spare or ascetic about his art; it's never short of vibrant.

3) The painting is always true to the book. That last point is important. It seems to me that a lot of professional artists don't like to read – their paintings often reflect the first scene in a book. Never once have I looked at a Walotsky painting and failed to recognize the work it illustrates. What's more, Ron connects with the work. I think the last three times he has painted a cover for *F&SF* the writer whose story he illustrated has asked about buying the original. That's not a fluke. That's a sign of an artist who brings his own talents to a story with respect, an artist who gets the author's work so adroitly that the cover illustration seems like a natural extension of the story. If that sounds easy, I'll introduce you to 60 unhappy authors and let them regale you.

My favourite American art tends to belong to the Hudson River school of the nineteenth century – Frederic Church and Thomas Cole could *see*. I think of Ron Walotsky as being one of the twentieth-century successors to that school – an artist who can peel back the façade of modernity and reveal the glory behind the everyday. Those swirling skyscapes are not our daily drudgery, they're the dreams we touch and share every day, and Ron brings them to us vividly.

Gordon van Gelder

Sketch, pen and ink

Facing page:
Candle in a Bottle
cover for *The Magazine of Fantasy & Science Fiction*, October 1996, illustrating the story by Carolyn Ives Gilman
42 x 55cm (16 x 22in), acrylic on board

There was a great dream sequence in this story, and so of course I took advantage of it. I always enjoy taking one kind of background and superimposing on it an image of a completely different kind – it can make for a very surreal painting.

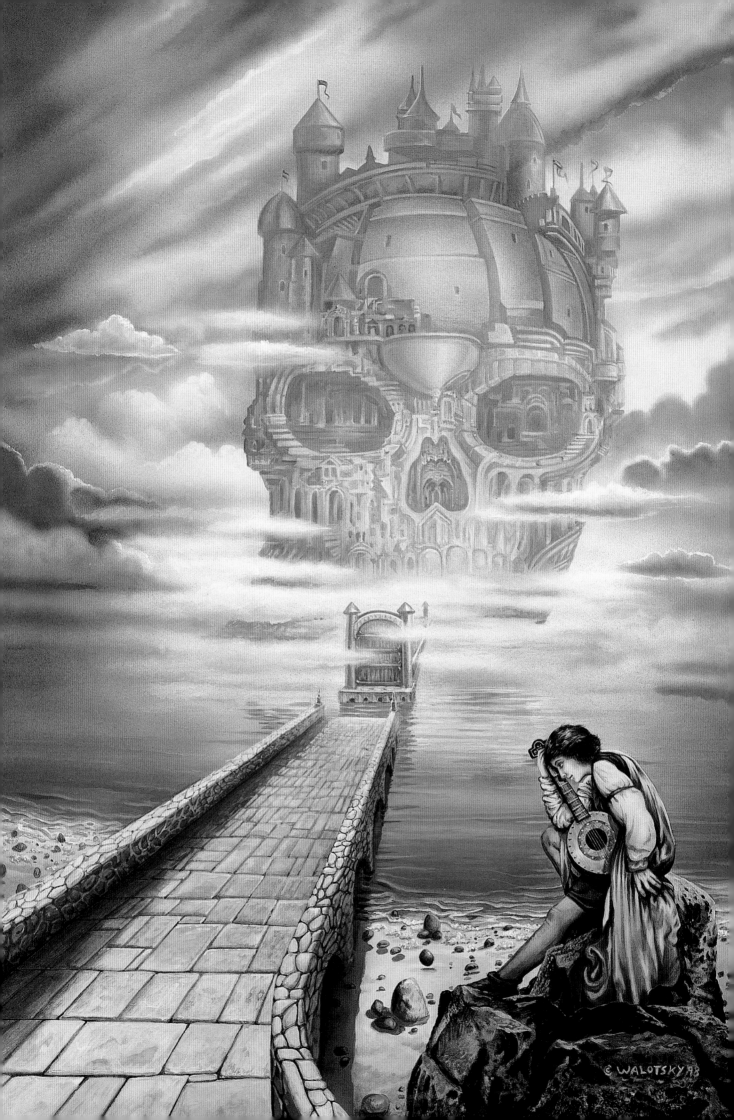

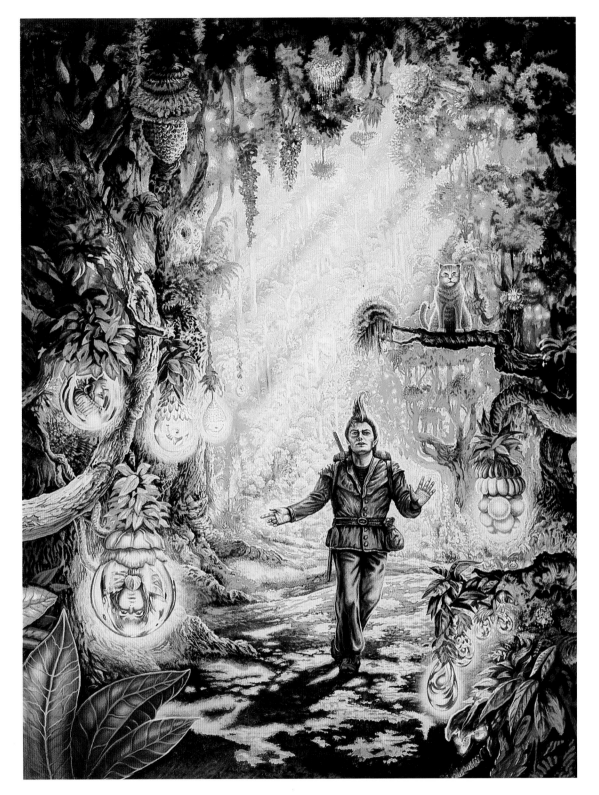

The Hestwood
cover for *The Magazine of Fantasy & Science Fiction*,
April 1999, illustrating the story by Rob Chilson
50 x 70cm (20 x 28in), acrylic on board

A fantasy forest with a human-like alien walking through it. Strange fruit hang from the trees. The sunlight streams through the branches. And the cat – somewhat like the Cheshire Cat – sitting on a branch seemingly indifferent to what's going on, but in fact fully aware of the viewer. These were wonderful visual images to work with. One thing you can't do in sf or fantasy illustration is give away the ending of the story. So I rarely take an image from the back of the book or story; I always try to keep the readers in suspense, making them curious as to what's inside and to the meaning of the image in the context of the story.

Facing page:
Island in the Lake
cover for *The Magazine of Fantasy & Science Fiction*, December 1998,
illustrating the story by Phyllis Eisenstein
50 x 70cm (20 x 28in), acrylic on board

ALTERNATE REALITIES

When I read a fantasy novel for the purposes of doing the cover I look for the most exciting parts of the book. I like to build on what the author is saying, and try to take it and turn it into my own personal vision – my own interpretation of the writing. The more far out and surreal, the better I like it.

Fantasy has no borders: you're supposed not just to go outside the lines but leap out of them – to try to do things people have never seen or, if it's something that they already know, to do it in a way they've never seen before. To me, fantasy art is not just a matter of churning out medieval-esque paintings: it can go from one point in the spectrum to another, juxtaposing opposite images to show realities that could never be, creating order out of chaos or chaos out of order. In other words, there are no limits.

Facing page:
Ancient Echoes
cover for the novel by Robert Holdstock, Penguin Roc, 1996
50 x 75cm (20 x 30in) acrylic on board

This was the first of three covers I did for Robert Holdstock's novels – the others were for Unknown Regions (page 36) and Gate of Ivory, Gate of Horn (page 35). All three relate in one way or another. The castle in the narrative moves through the ground and also through another dimension – sort of like the castle in Diana Wynne Jones's Howl's Moving Castle. The image of a tattooed girl that the boy in the story keeps seeing is yet another mask (masks do keep popping up in my work over the years!). The fun part of this painting was fitting the images of the animals into the pillars.

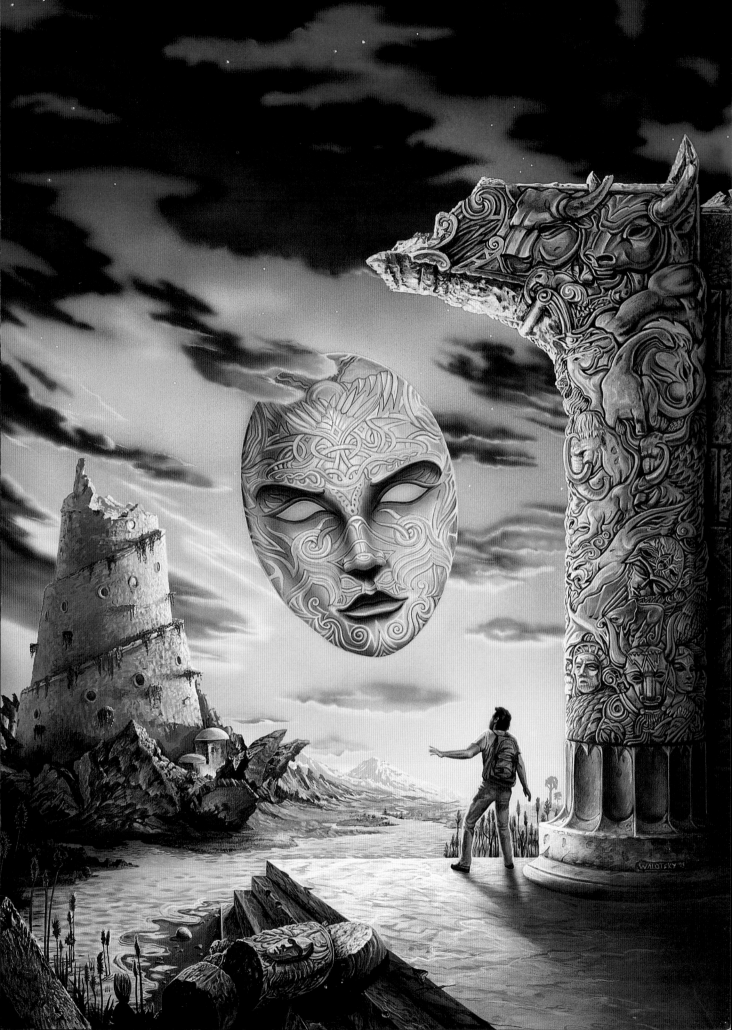

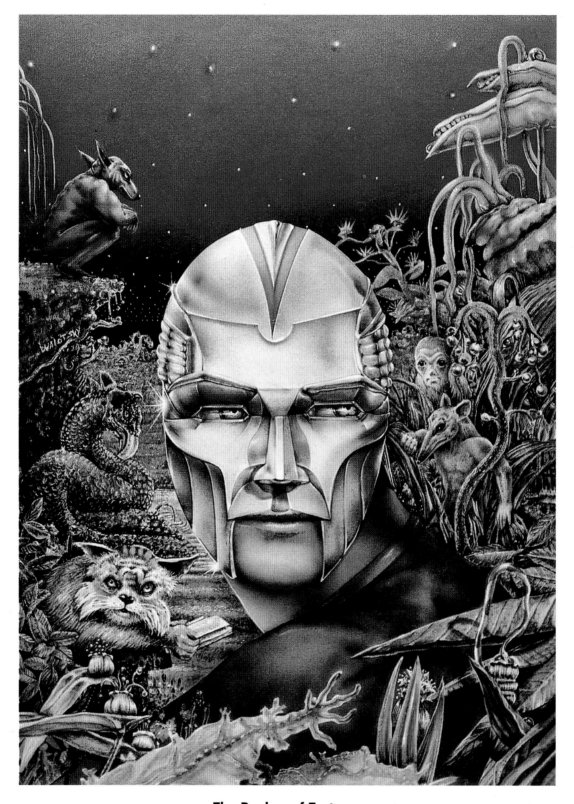

The Realms of Tartarus
cover for the novel by Brian Stableford, Daw, 1977
40 x 50cm (15 x 20in), acrylic on board

*In the story a man finds himself on a planet where he is surrounded by fantastic creatures. Just portraying him
in the middle of a bunch of them seemed the best way of showing all the different alien lifeforms described
in the book. After all these years I can't recall why he has a mask on . . . but you already
know about me and masks.*

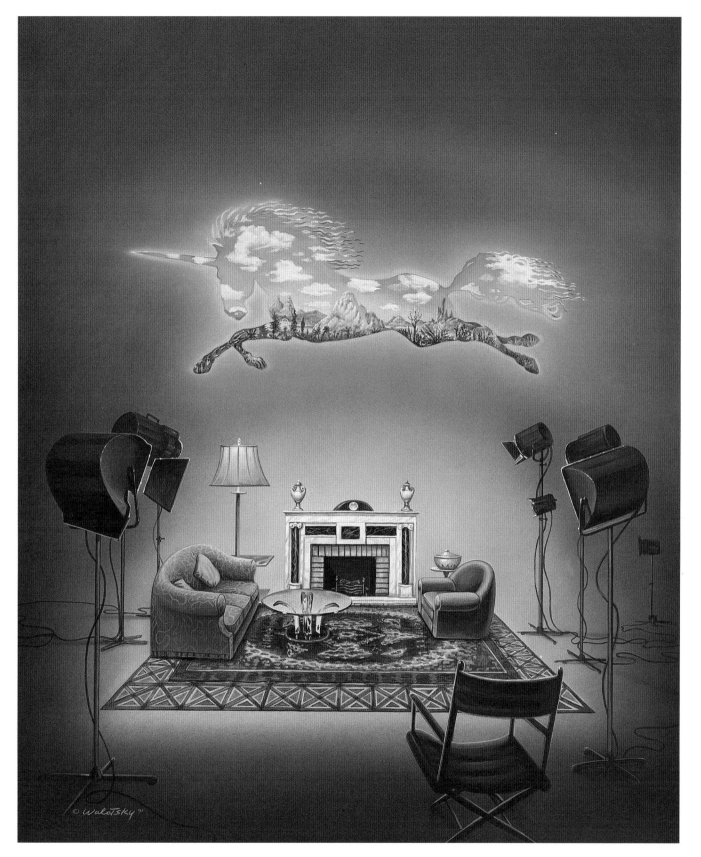

Fantasies
interior for *Amazing Stories*, August 1991, illustrating the story by Michael Swanwick and Tim Sullivan
40 x 50cm (15 x 20in), acrylic on board

*I wanted to capture the image of a unicorn jumping through a different dimension, appearing and disappearing
on a movie set. I decided to depict the other dimension within the outline of the unicorn's body. I thought this
shed light on the story in a simple yet profoundly surreal way. When my editor on the current book first saw
this image he got very excited and said this was one of those rare pictures that show exactly what fantasy is about.*

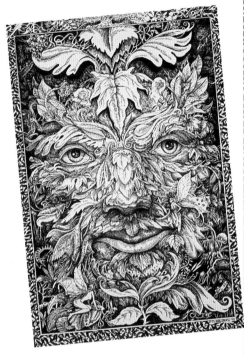

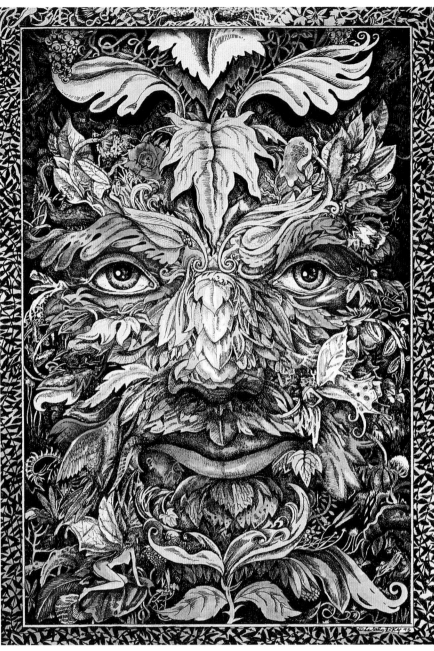

Trailblazing

The fantastic art of Ron Walotsky descends from a trend of non-traditional imagery that has its roots in Surrealism and in the seminal science fiction work of the influential talent Richard Powers. Walotsky's entry into the field in the late 1960s, concurrent with the literary movement in sf known as the New Wave, helped give that special brand of science fiction its unique, artistically sophisticated visual identity; other illustrators at the vanguard of the movement included Don Punchatz and Gervasio Gallardo. Walotsky has continued to be among the field's most innovative trailblazers and, to boot, still manages to be one of the great and likeable gentlemen of the genre. After more than three decades working in the sf/fantasy field, his work still manages to dazzle the viewer and,

for those of us who toil in those same hallowed vineyards of the fantastic, it remains a constant source of novelty and inspiration.

As evidence of his enduring fame and popularity, Walotsky's work has become a fixture at *The Magazine of Fantasy & Science Fiction*. He has received numerous awards – including the coveted Frank R. Paul Award for Outstanding Artistic Achievement and still remains ubiquitous on the sf book and magazine racks while many other so-called superstars of sf/fantasy art have long since faded from view. That there is finally available, after these many long years, a sumptuous volume of Walotsky's exquisite work is an sf-art lover's dream come true.

Vincent Di Fate

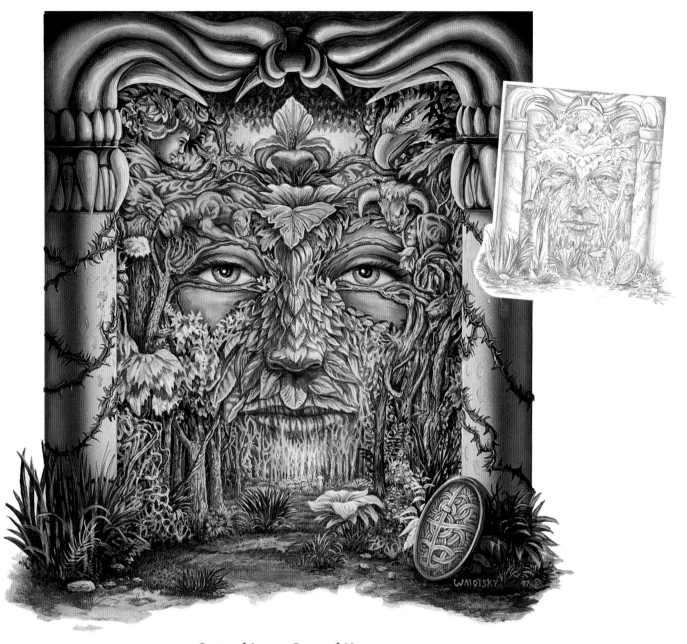

Gate of Ivory, Gate of Horn
cover for the novel by Robert Holdstock, Penguin Roc, 1997
40 x 45cm (15 x 18in), acrylic on board

*Penguin Roc had seen my pen-and-ink picture The Benedictions of Pan (facing page) and liked the idea of all the hidden images.
They wanted me to use the same concept for the cover of this novel – appropriately enough it's one of Holdstock's "Mythago Wood"
sequence dealing with other realities. Any time you're out walking in the woods there are always strange images lurking around
that you can almost see, but not quite. It was that feeling that I was trying to create in this painting.*

Facing page:
The Benedictions of Pan
title page for the novel by Don McFarland, Healing Arts Press, 1992
25 x 35cm (11 x 14in), pen and ink on watercolour paper

*I was delighted when Don asked me to create the title-page illustration for his book, because it allowed me to express my
interpretation of Pan, a being who has been a subject for countless artists throughout history. Pan was important to pagan
harvest festivals and this has carried over into more recent times: I found out there were a lot of Pans on the cornerstones of
Christian churches. I wanted the picture to have the flavour of an old print, and so I chose to do it in pen and ink.
While I was working on it I decided to include forest animals and elements from fable, and you'll find these hidden
throughout the piece – have a look and see if you can find them. Afterwards I did the colour version and made
limited-edition prints of both pictures.*

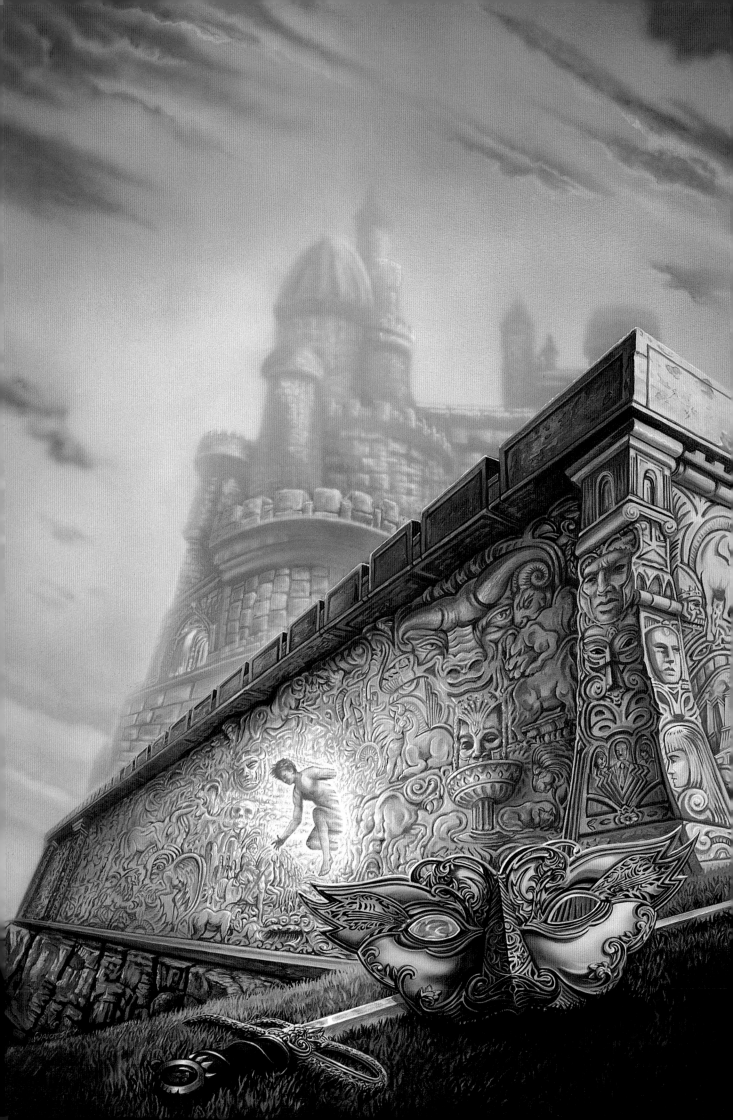

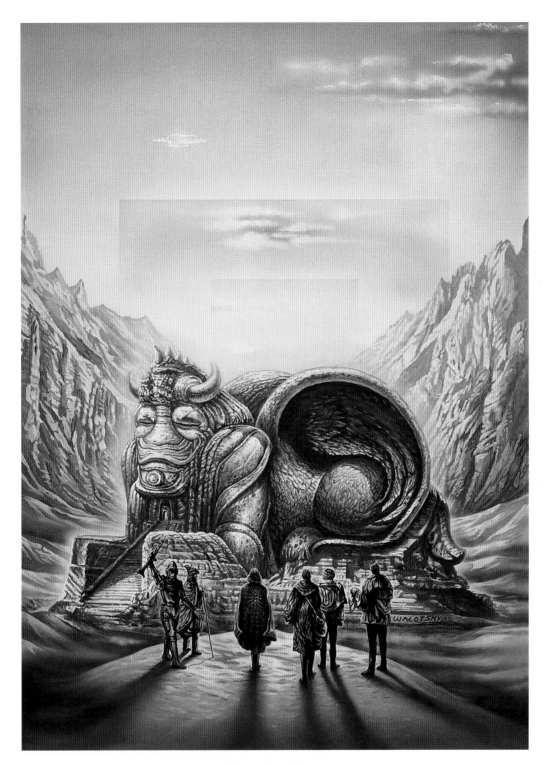

Hyperion Cantos
cover for the omnibus by Dan Simmons, Science Fiction
Book Club, 1990
50 x 70cm (20 x 28in), acrylic on board

*I enjoy doing "the quest thing" with a painting – showing a group of people who're in the process of a quest.
In this case it's an alien monolith, part sphinx and part some unknown creature, that they've finally reached.
Creating the impression of its hugeness was also a concern, as it so often is when painting fantasy or sf art.*

Facing page:
Unknown Regions
cover for the novel by Robert Holdstock, Penguin Roc, 1996
50 x 75cm (20 x 30in), acrylic on board

*The wall was the part I really got into painting: fitting into it all the images that are in the book. Then there's the boy
bursting through into the other dimension: here the images are soft, almost dreamlike, to evoke the feeling of the
book. I always try to create the same emotional effect in the cover illustration as I get from the book itself, one of the
main reasons why I prefer to be given the entire manuscript rather than an art director's brief.*

Joking Apart

We've known Ron for what seems like a lifetime. So long, in fact, that we're hard-pressed to come up with the year we first met; in any event, it was surely a case of "instant simpatico".

Before we met face-to-face, however, we had already been attracted to his dreamily mystical and surrealistic approach to well-worn science-fictional themes, and by his bold use of colour and fearlessness in attacking unconventional concepts in unconventional ways. Then we met him, and decided he was just the kind of artist who might easily have been a long-lost brother.

Although by the time of our first meeting – which must have been at a science fiction convention in New York back in the late 1970s – we were familiar with his stylish and colourful illustrations for magazines and books, Ron had kept silent for years about the large body of his abstract, non-sf paintings. At some point, though, we must have crossed the threshold in Ron's mind from acquaintances to friends because one day, out of the blue, came a stack of photographs and we were treated to a journey through Ron's other artistic life – that of the contemporary "gallery" artist. The photos were irresistible and so, one weekend long ago, we set out on a pilgrimage to his house, then located in Long Island, New York.

There we discovered a rather quiet yet very articulate person living in a conventionally designed ranch house, decorated with the painted shells of horseshoe crabs and odd constructions of wood and metal – his hobby – and of course marvellous paintings! Amid the clutter of art in progress, he graciously conducted us on a tour of closets filled with art and walls covered with examples of his own colourful abstract art (an eye-opening experience!). Somehow we never had grasped his true versatility; we saw rock album covers and posters from his "psychedelic" period mixed in with magazine illustrations from instantly recognizable publications like *Playboy*. And in the process we discovered his charming personality and subtle sense of humour – and instantly decided he should be a member of the Frank family. That sense of humour is a quiet presence in much of his art – especially his "aliens" – although the surface themes would not seem to support it. It was that element that first attracted us to his cover art for the 1988

Doubleday edition of *Return to Eden*, a novel by Harry Harrison. The central figure was an imperious reptilian creature, to be sure, but also quite cute.

One of the earliest pieces we acquired from Ron, *Limits* (done for the cover of the Larry Niven book; Doubleday 1985–1986) depicts a common scene made special by Ron's presence in it. This is a spaceport bar populated by all sorts of strange creatures,

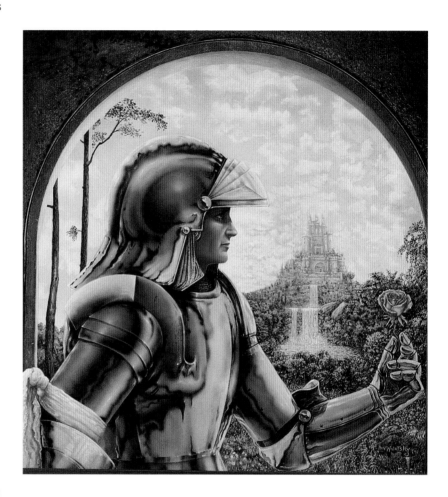

who are being tended to by a very charming barman. Only the most diehard alien-hater would fail to smile at this bartender, hard at work polishing glasses. Those who know him quickly realize that the barman is none other than Ron himself. Those who don't are deprived of this extra element of humour embedded in what is already a very humorous painting.

Some time later Ron painted *Cortez on Jupiter*, a fabulous painting that we felt compelled to buy. Cortez combines Ron's more traditional sf illustration with his wilder gallery art, filled with fantastic symbolism and eye-opening colours. Cortez, the artist, again is surely Walotsky, the artist, in disguise. The spaceship emblem being painted by Cortez also existed as a 1.5 x 1.5m (5 x 5ft) oil painting, most likely still hanging on Ron's wall. We had no room in our house for

that masterpiece, and so chose *Cortez* instead – the science-fictional version!

We've shared many a lunch and many a dinner and many hours talking with Ron. He's always working on something new and something challenging, whether it's an illustrated children's book or another cover for *The Magazine of Fantasy & Science Fiction*, a publication which, over the years, has used dozens

Lancelot and Guinevere
private commission, 1978
each 50 x 45cm (20 x 18in), acrylic on board

Two paintings that are both separate and together – a reflection of the nature of the classic legend. Lancelot is presenting the rose to Guinevere, but she is turning slightly away, realizing the conflict her acceptance of it will cause.

of Ron's paintings for their covers. And, perhaps unsurprisingly, we continue to be astounded by Ron's range of artistic talent – most recently by intricate pen-and-ink pieces that would challenge many of the finest practitioners of this special art form. The first version (created in 1992) of a highly detailed rendition of a Green Man, which Walotsky titled *The Nature of Pan*, was a charming pen-and-ink composition full of intricate, delicate figures, half hidden in complex

patterns, which combined to create a visual treat. It was so different from the full-colour acrylic paintings that we had come to associate with Ron's work that we were immediately drawn to it. It made a smashing T-shirt design, as well – as Ron discovered – and it was fun to wear the art that we had on our wall (just one of the many bonuses of collecting illustrative art!). Then in 1997 the artist, to our surprise, received a commission from Penguin/Roc Books to do the cover for a novel by Robert Holdstock, *Gate of Ivory, Gate of Horn* that enabled him to create yet another version of the same image, this time in full colour. We could not resist acquiring this picture as well, and it is intriguing to see them both hanging together.

Ron's versatility as an artist has led him to some interesting artistic byways, not all of them related to the genre of literature we enjoy most – science fiction and fantasy. Recently, in fact, Ron has been producing some wonderfully inventive personal works, quite surreal and utterly appealing. We don't exactly know what's going on when we look at them, but we like them a lot! And isn't that the point, after all? These works are not as readily accessible to viewers but they exude such a rare and powerful charm that one cannot help but be pulled into "Ron's World". These colourfully surreal paintings have such innocent appeal that, while knowing there is depth to the symbolism there, the viewer can forego analysis and just enjoy them for the emotions they evoke. We hope he continues to explore this artistic avenue, but there's no way of telling with Walotsky, whom we know will persist in experimenting with ideas for as long as he paints.

No matter what subject matter this artist tackles, his unique visual signature will always captivate the eye, and compel the viewer to take notice. We're confident that readers of this book will be as invigorated and entertained by his imagery as we have been all these years.

Jane and Howard Frank

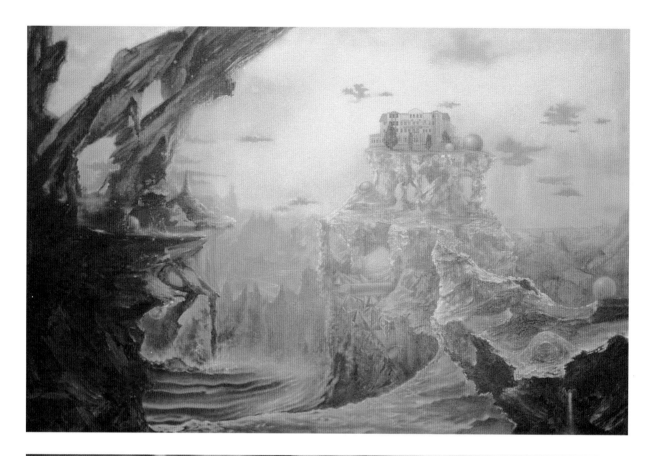

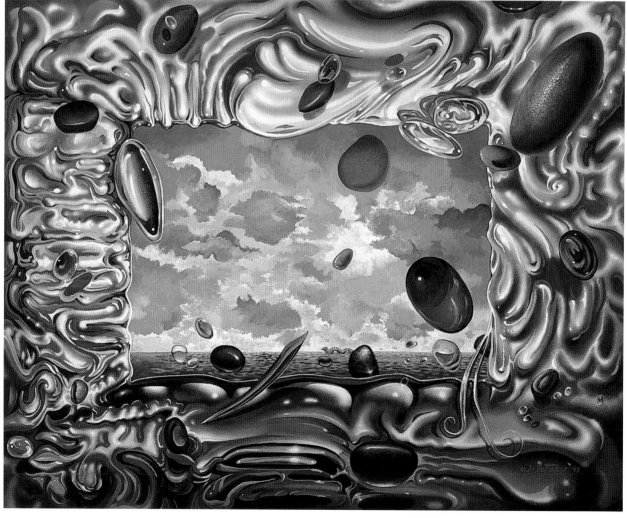

Right:
The Compass Rose
unpublished work, 1988
30 x 30cm (12 x 12in), acrylic on board

This was to be a cover for a collection of stories by Ursula K. Le Guin, but it was never used. Anyway, I liked the painting so I did prints of it and it ended up being one of my top-selling prints. I've always enjoyed doing spot images, and here I liked the silver frame with the unicorn, lion and four points of the compass, and the dreamy, slightly romantic image inside.

Facing page, top:
Landscape with Hotel
personal work, 1979
1.2 x 1.8m (4 x 6ft), acrylic on canvas

While I was living in the Catskill Mountains, from time to time I would come across deserted hotels. These fascinated me, and this painting is the result.

Facing page, bottom:
The Sea Dragon
personal work, 1997/1998
50 x 60cm (20 x 24in)
acrylic on canvas

A combination of abstract and figurative concepts. I've used certain elements over and over through the years: a square within a square or rectangles within each other, so that the frame becomes part of the painting . . . or sometimes even the whole painting. The effect is one of pushing out the boundaries, of creating tensions that move the painting out of the confined space of the canvas.

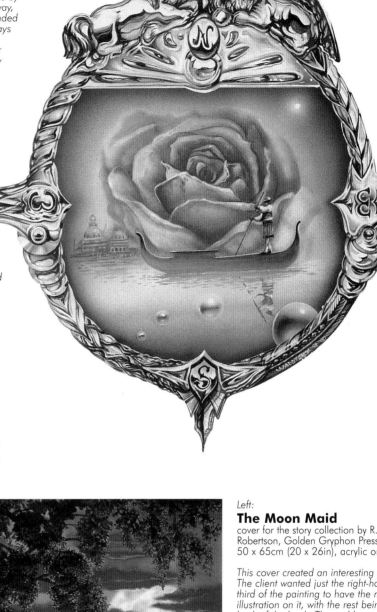

Left:
The Moon Maid
cover for the story collection by R. García y Robertson, Golden Gryphon Press, 1998
50 x 65cm (20 x 26in), acrylic on board

This cover created an interesting problem. The client wanted just the right-hand third of the painting to have the main illustration on it, with the rest being on the back of the book. The problem was to make the woman on the front looking away from the spine of the book, but remaining an integral part of the painting. In the story she uses a bow and arrow to shoot a lion that has been her friend, so the reason for her turning away from her friend and the rest of the pride is that she doesn't want them to see she's stringing an arrow onto her bow. I'm satisfied that I took care of the design dictate as well as producing a picture that works as a whole.

The Crystal Palace of Adamas
cover for the children's book by Richard M. Wainwright,
Family Life Publishing, 1995
42 x 70cm (16 x 28in), acrylic on paper

*Nearly 30 years into my career and this was the first children's book
I'd done – not just the cover (shown here) but the 38 internal
illustrations as well. It was also Richard's first science fiction book, so
it was a new experience for him, too. We found working together
very rewarding.*

*I wanted the illustrations to be fairly realistic, so I took photos of
friends and family members as reference for the characters in the
book. The other thing I wanted to do was to convey a light, open
feeling to reflect the story's ecological message – how not to destroy
your resources.*

A couple of years later, in 1997, we produced another book together, *Nana, Grandpa, and Tecumseh*, about the death of a grandfather and how children handle the grief of losing a family member. And as of this writing, we're in the early stages of our third book, *Messengers*, about a boy's growing awareness of his surroundings and the people in his life.

As you'll guess from all this, Richard strives to convey positive messages through his writing.

Walotsky in the Sky with Diamonds

Picture yourself in a boat on a planet . . .

One could easily imagine oneself inside a Ron Walotsky painting. Sort of like a dream of being on a far-off world – somewhere you might like to wander off into, away from this jarring reality, and stay there contemplating the chroma around you.

His early covers for *The Magazine of Fantasy & Science Fiction* are among the ones from that magazine I remember the most.

There is always much, much more than the obvious going on in Ron's paintings. As with Monet, we see colours placed next to other colours creating entirely new illusions of colours that we thought could never exist. Ron's use of colour literally trademarks his work into a style that could only be called his own.

Ron is what I would call a Sixties kind of guy. And I say that with a great deal of respect. He's from a generation of artists who saw, first-hand, real change happen in society, in an explosive and consequently

artistic way. He's a Renaissance man in every regard. He knows there is nothing like the tactile feel of paint on canvas. Ron, like myself, also rejects the overused and uniform-looking "computer" art. Not so much the medium used, but the non-creative hands which are convinced that visionary work can be simply typed up on a keyboard with a monitor and an incomprehensible programme.

Personally speaking, Ron is one of the coolest guys in the business. He's great just to sit and talk art with. He's also a true painter in the sense that he paints outside. Ron believes that when artists paint outside they "are connecting with the true artistic lineage of all the great masters". I can only agree with him.

Ron Walotsky knows his own place in the universe, because he's probably painted all the other places as well.

Bob Eggleton

Facing page:

From the End of the Twentieth Century
cover for the story collection by John M. Ford, NESFA Press, 1997
40 x 50cm (15 x 20in), acrylic on board

Trains were at the heart of some of the stories in this collection, and so I made a train the main focus of my cover illustration. All the other images in the picture were, as always, drawn from different stories, I had fun putting unrelated images together to make a unified whole, and the fact that the cover was being done for NESFA Press, one of my favourite organizations, made my enjoyment even greater.

Sketch for *From the End of the Twentieth Century*
pencil

I originally wanted this sketch to look like the space shuttle taking off, except for the train. We changed the idea, however, before I did the final artwork.

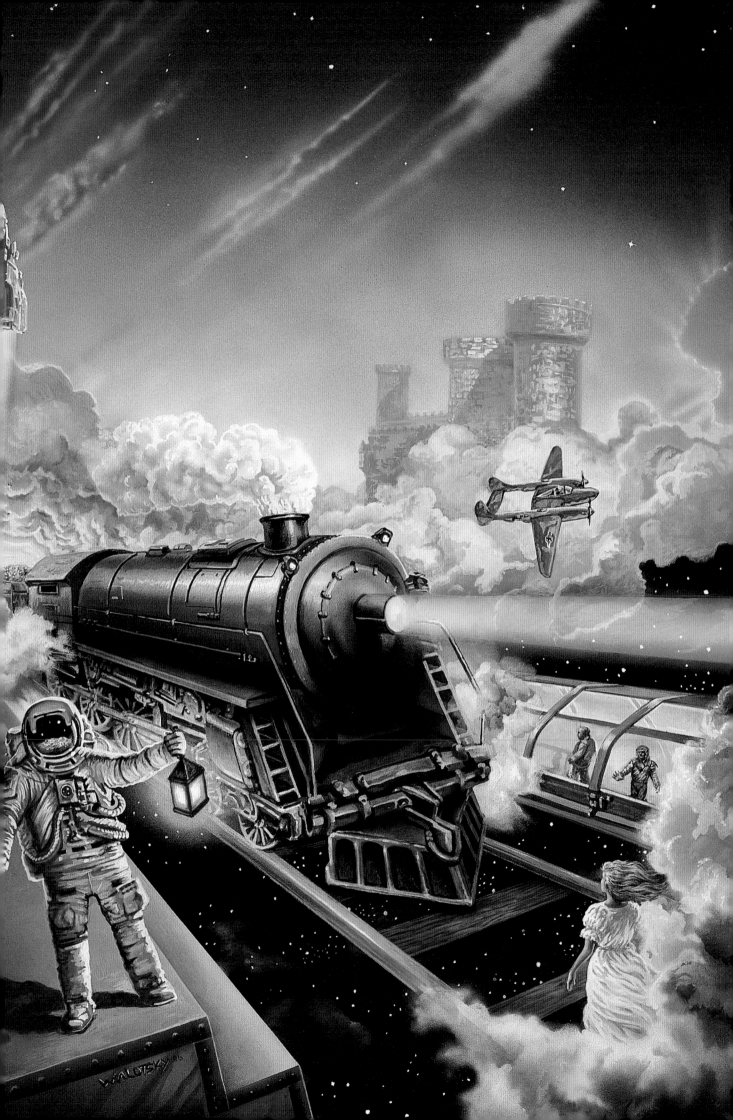

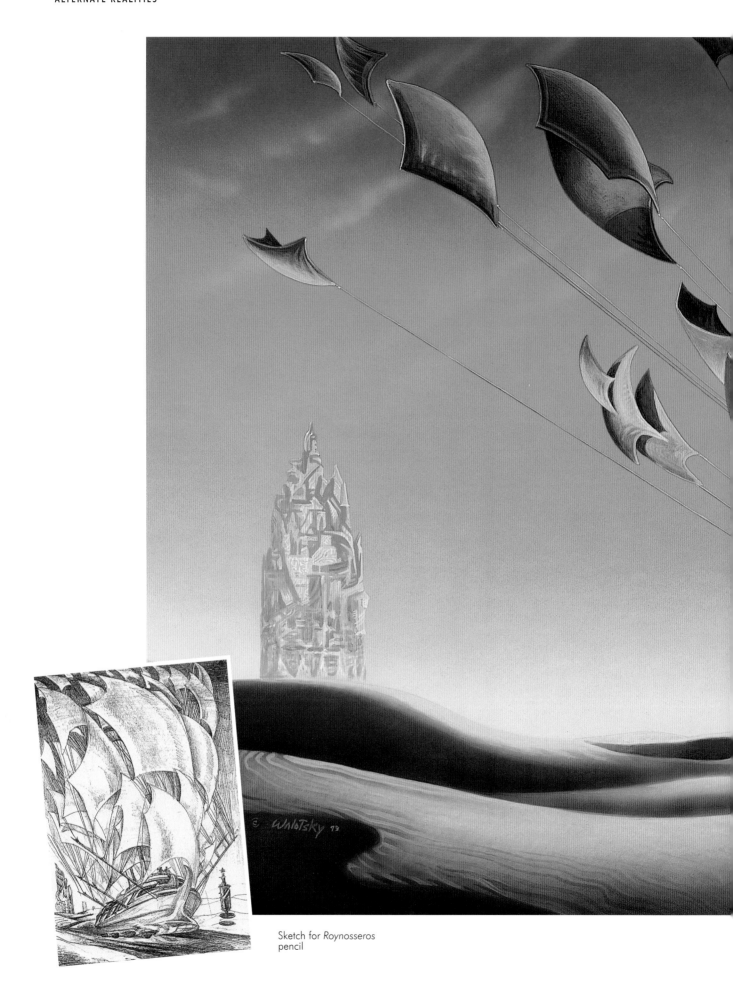

Sketch for *Roynosseros*
pencil

46

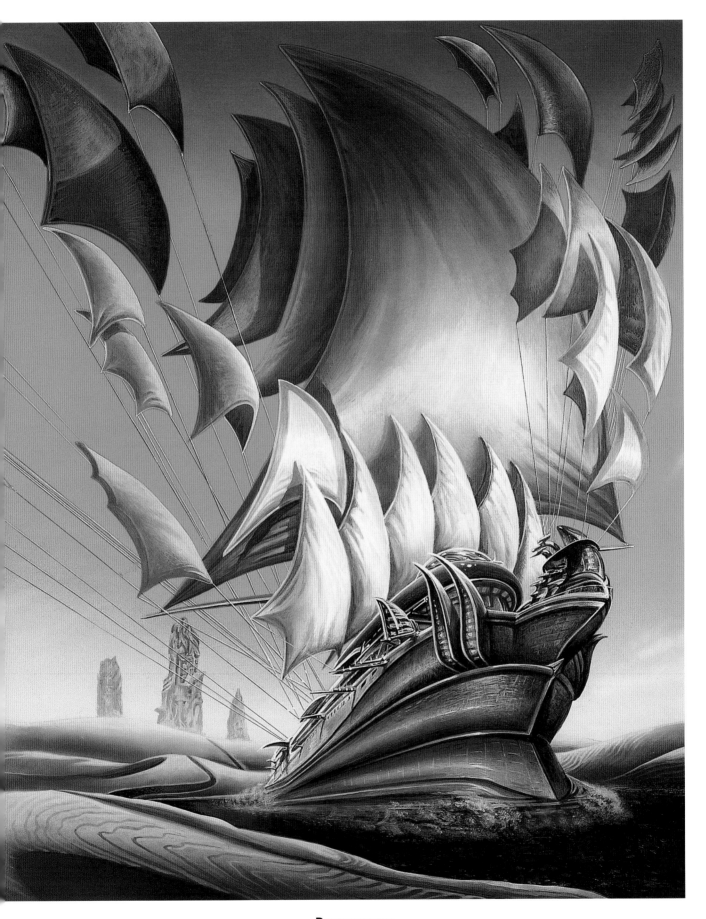

Roynosseros
cover for the novel by Terry Dowling, Science Fiction Book Club, 1989
50 x 75cm (20 x 30in), acrylic on board

Mystical
cover done in the mid-1970s
30 x 35cm (12 x 14in), acrylic on board

*I'm afraid I've now forgotten everything about the book for which I produced this cover – title, author, publisher, everything!
I still like the painting a lot, though, which is why I've included it here.*

Facing page:
The Malacia Tapestry
cover for the novel by Brian Aldiss, Easton Press, 1996
50 x 70cm (20 x 28in), acrylic on board

*This vintage fantasy has wonderful images to work with – gaudily coloured balloons, medieval costumes and the rest. I was given the text
and told to come up with my own ideas, and there was plenty of material for me to choose from. But the artist isn't always so lucky.
Sometimes you get a text which offers you very little by way of visual cues and so you have to create something out of your own head –
in terms of design, colour values or dramatic images, or all three – that will make people sit up and take notice. That's the bottom line
in cover illustration – selling the book. If the author's not well known (not a problem with this particular book, of course) then the
publisher is relying on the artist to generate impulse sales.*

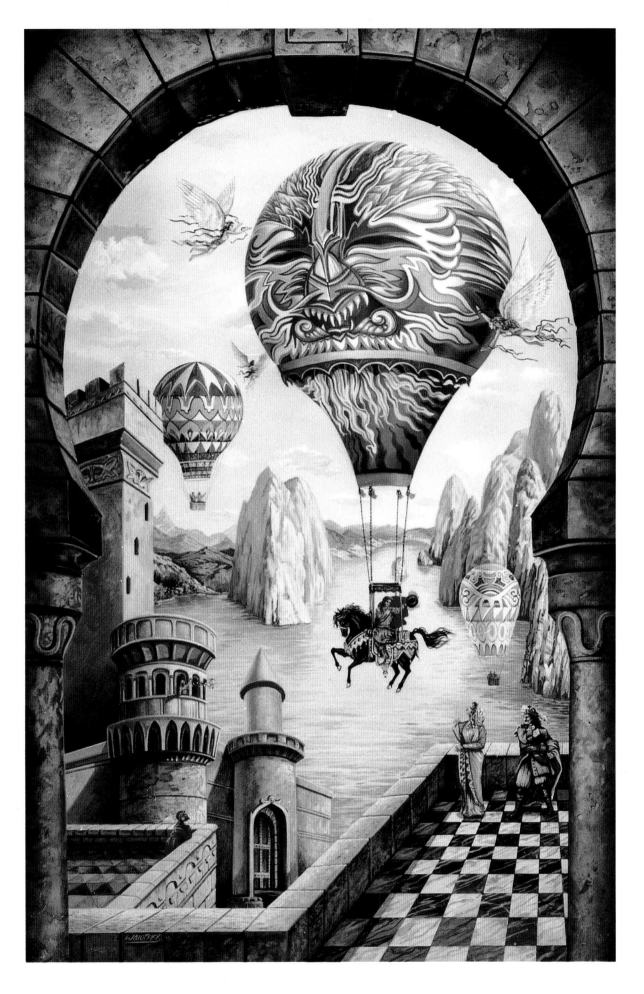

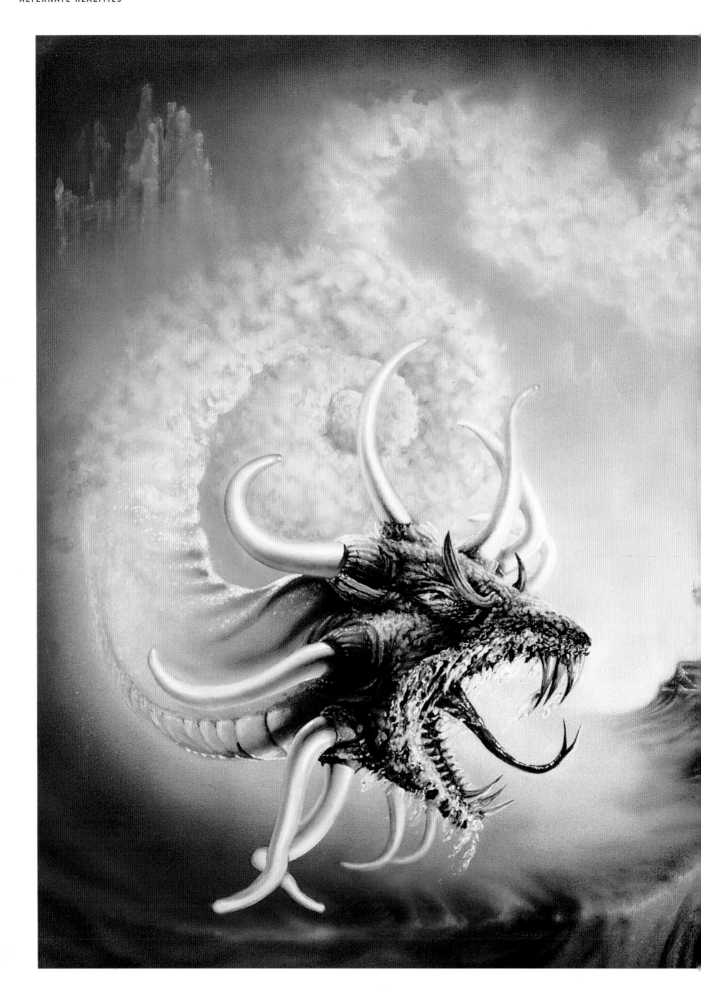

Conan the Invincible
cover for the novel by Robert Jordan,
Tor, 1982
60 x 75cm (24 x 30in), acrylic on canvas

*Tor asked me to do three wraparound
covers for Robert Jordan's continuations
of Robert E. Howard's "Conan" series.
This was a bit of a daunting assignment,
since the archetypal Conan artist is
Frank Frazetta! Despite the huge differ-
ence in style between us, I had to give
the paintings the same feeling so that
there would be some sense of continuity
with the earlier books.*

Right:
Carrie
cover for the novel by
Stephen King, G.K. Hall, 1992
40 x 50cm (15 x 20in),
acrylic on board

*I was naturally pretty pleased
to be asked to do a Stephen
King cover. With an author of
this stature, however, the
illustration is given only
secondary importance in the
design of the cover: pride of
place is given to the author's
name. The bigger the type the
smaller the picture, of course,
and in this instance G.K. Hall
wanted me to do a spot
illustration. I decided the best
thing to do was just show
Carrie's face, to try to
capture the sense of the story
in her eyes.*

Below:
Wolf Head
logo design for a rock band,
1981
10 x 10cm (4 x 4in),
coloured pencils on paper

Facing page:
The Crow: Shattered Lives, Broken Dreams
cover for the anthology edited by J. O'Barr and Ed Kramer,
Ballantine, 1998
50 x 75cm (20 x 30in), acrylic on board

*One of the stories in this anthology was "The Procrastinator" by
Alan Dean Foster, which I chose as my subject. I wanted to keep the
image simple – not something I do very often – but in fact the end-
result is visually a fairly complicated piece. The crow and the shadow
become a mask. The white space around the shadow of the crow's
head forms two faces looking at each other (I was intrigued by the
concept of making negative space positive). So the image is really a
triple one, as befits a story about switching souls. I consider this to
be among my more successful paintings.*

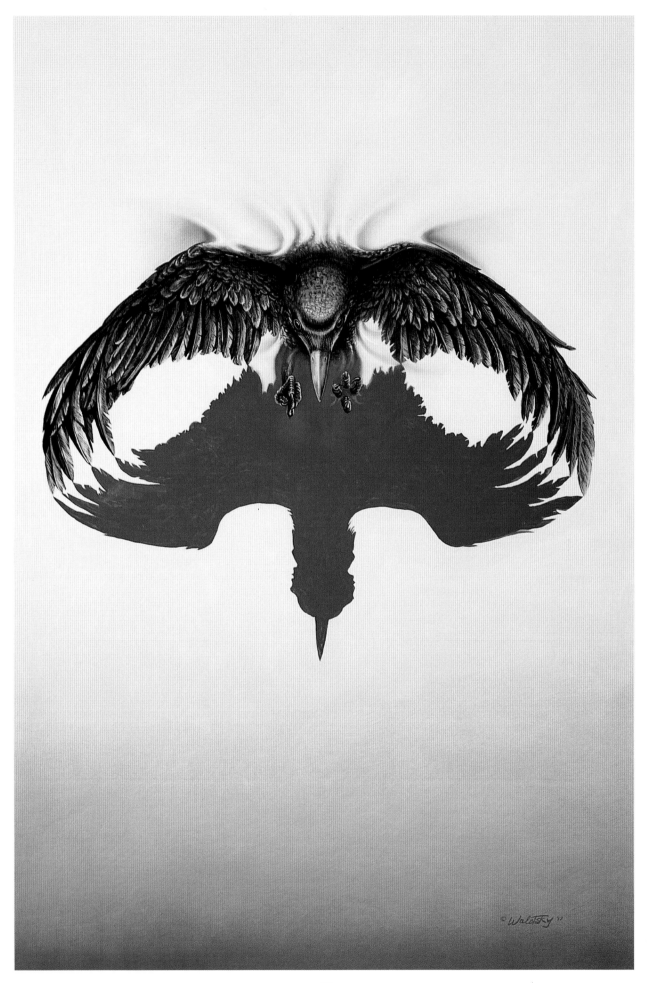

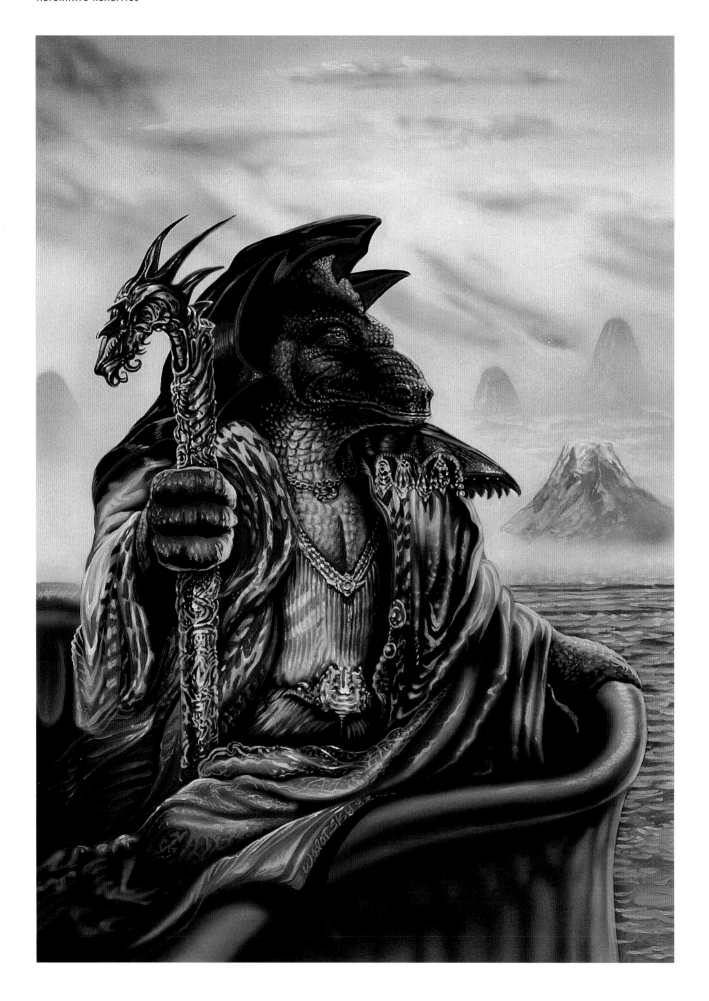

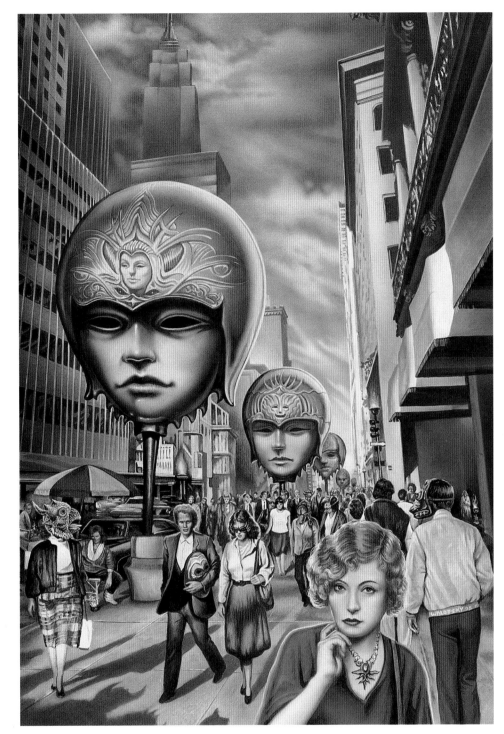

Right:
Temporary Agency
cover for the novel by Rachel
Pollack, St Martin's Press, 1994
40 x 50cm (15 x 20in), acrylic
on board

*Gordon van Gelder at St Martin's
sent me the manuscript for this
alternate-world story, and I was
delighted to find it was full of
masks and spells – yet another
perfect opportunity for me to
incorporate masks into one of my
paintings! So I set about turning
New York's Sixth Avenue into
somewhere strange and surreal,
right down to the lowliest hot-dog
stand – a place where magic
was commonplace.*

Sketch
mixed media

Facing page:
Return to Eden
cover for the novel by Harry Harrison, Science Fiction Book Club, 1988
40 x 50cm (15 x 20in), acrylic on board

ROBERT SILVERBERG

I was very taken with a novelette by Robert Silverberg which I read when F&SF commissioned me to draw the cover for it. The novelette was part of what would become Lord Valentine's Castle, and this commission was the beginning of a long association between me and that book. Not long after the F&SF appearance, Harper & Row asked me to do the illustration for their hardcover edition of the novel; because this was a wraparound I felt I had acres of space, and so I did a painting that evoked a feeling of vast scale. Then, a lot later on, Easton Press asked me to do a version of it for the title page of their limited edition of the novel. Finally, the Science Fiction Book Club commissioned a cover painting from me for their edition of Valentine of Majipoor, which is the trilogy of which Lord Valentine's Castle is the first novel. So, over the years, this single book has come back to me four times.

Of course, I've illustrated other works by Robert Silverberg as well and I've reproduced some of the covers on the next few pages.

Facing page:
Born with the Dead
cover for the novel by Robert Silverberg, Tor, 1988
50 x 75cm (20 x 30in), acrylic on board

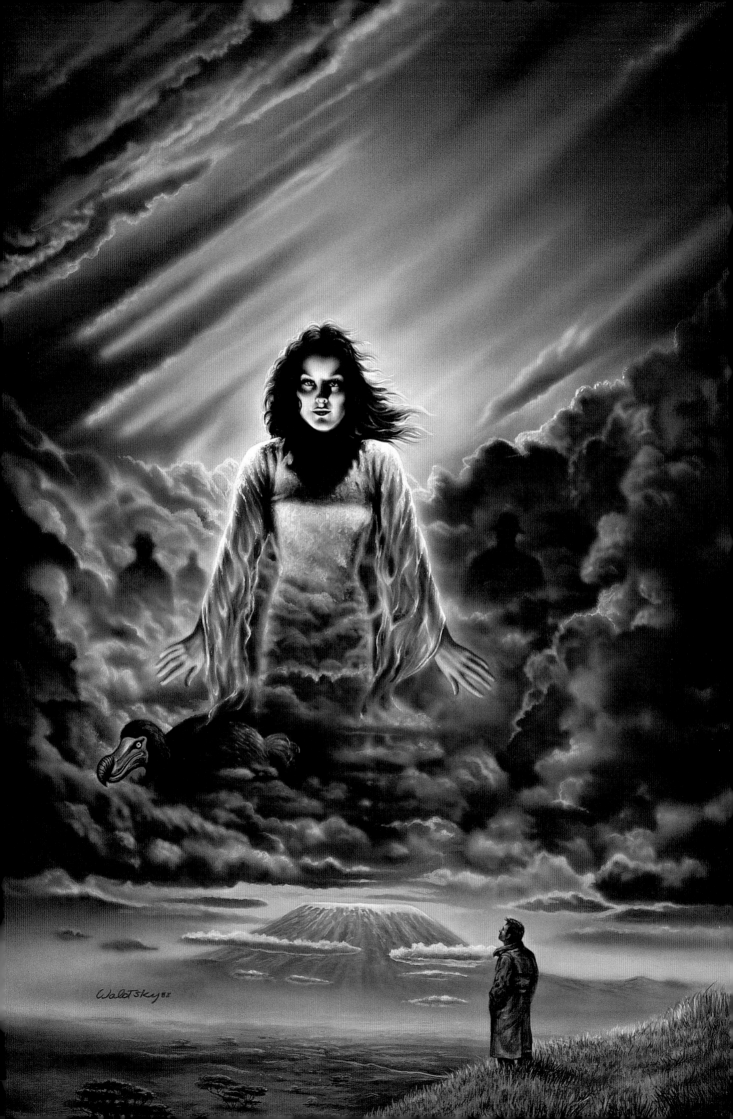

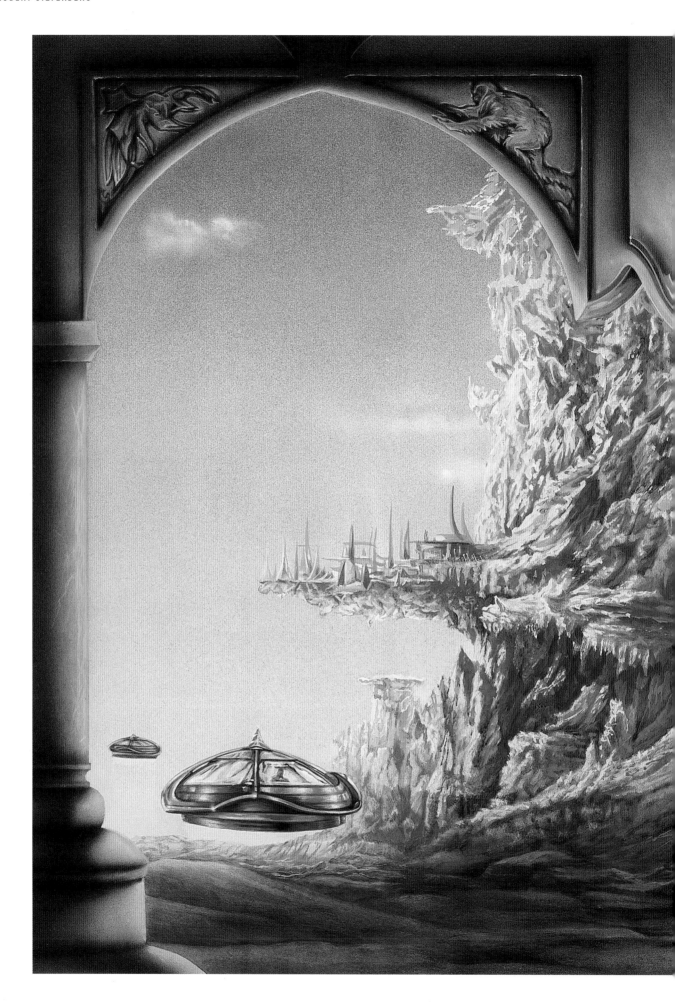

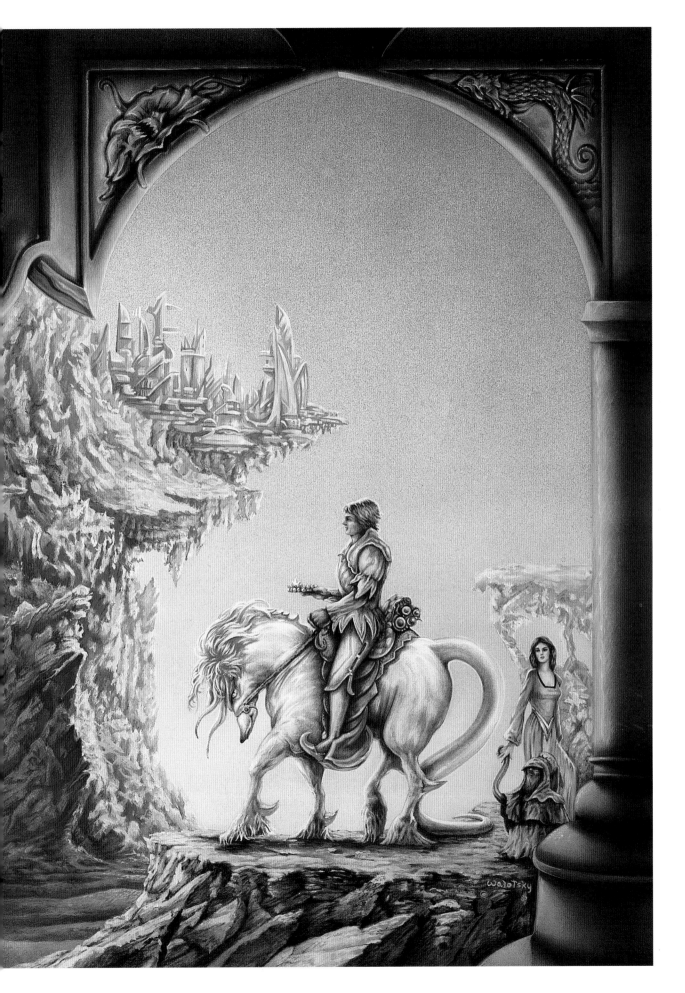

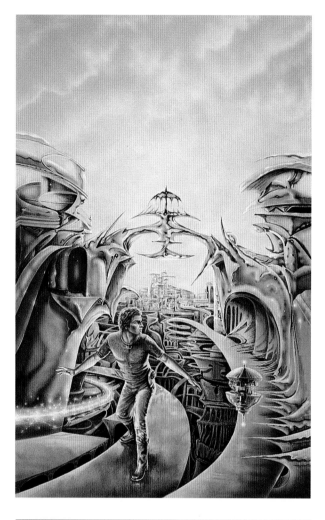

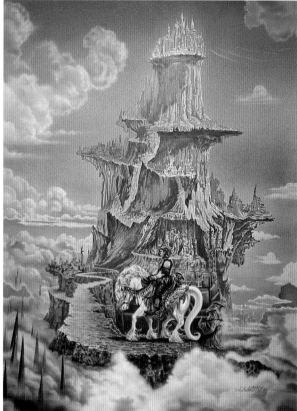

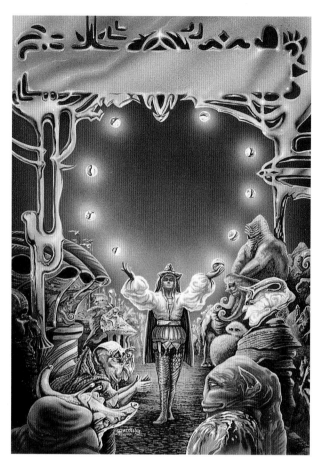

Previous pages:
Lord Valentine's Castle
title page for a novel by Robert Silverberg,
Harper & Row, 1980
50 x 75cm (20 x 30in), acrylic on board

Above:
Lord Valentine's Castle
cover for *The Magazine of Fantasy & Science Fiction*,
November 1979, illustrating the lead story by Robert Silverberg
40 x 50cm (15 x 20in), acrylic on board

Above left:
The Man in the Maze
cover for the novel by Robert Silverberg, Avon Books, 1978
45 x 60cm (18 x 24in), acrylic on board
*This was interesting to do, creating the strange and mystifying alien
city and having the man lost in it, not knowing which way to turn.
I chose to express his confusion through my portrayal of him.*

Left:
Lord Valentine's Castle
title page for a novel by Robert Silverberg, Easton Press, 1997
50 x 75cm (20 x 30in), acrylic on board

Facing page:
Valentine of Majipoor
cover and poster for the omnibus by Robert Silverberg,
Science Fiction Book Club, 1999
50 x 75cm (20 x 30in), acrylic on board

*This one kind of takes all the Lord Valentine covers I've done and
puts everything into one. I wanted to create a landscape that would
just draw your eye in and then keep it moving back into the distance
as far as you could see until finally you came to the castle, roaming
en route through the rest of the landscape with its villages and its
neverending mountains. The SFBC used part of the painting for the
cover and the whole of it as a poster that came free with the book.*

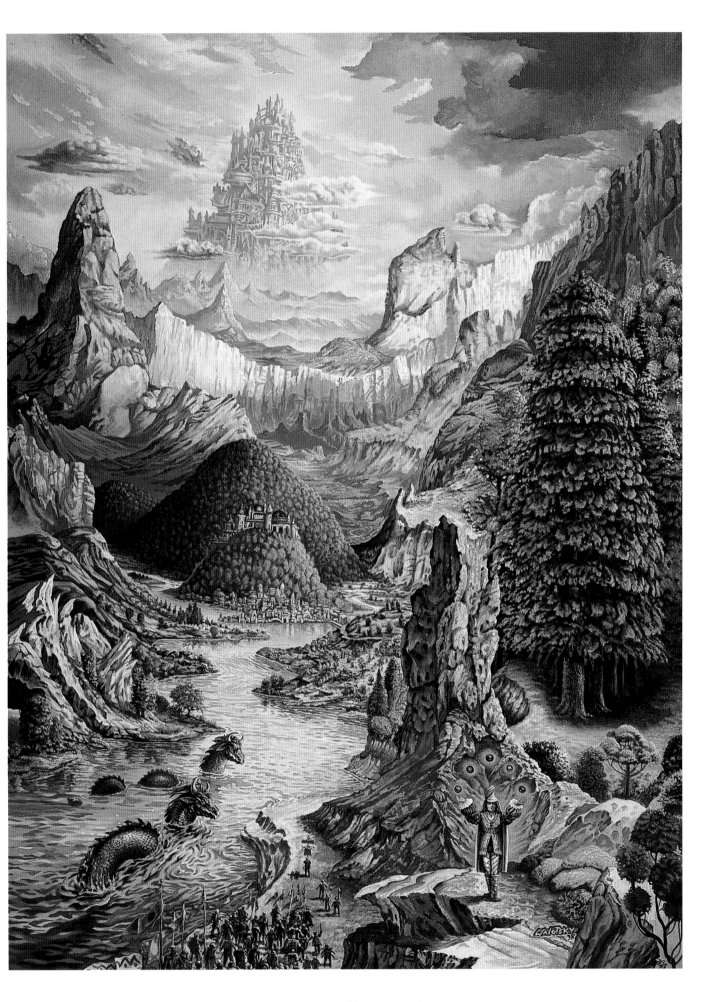

PIERS ANTHONY

It was in the 1970s that Avon Books asked me to do a series of covers for Piers Anthony's novels. That began a long association with him; I've done his covers not only for Avon but also for the Science Fiction Book Club.

Piers has so much visual imagery in his writing that sometimes it has been hard to pick out just a single idea to use as the basis for the illustration. So I would take elements from several different scenes and combine them into one coherent painting. The Avon covers had an overall style to them, the borders and archways serving to unify all the books in the series.

Facing page:
Ghost
cover for the novel by Piers Anthony, Tor, 1986
50 x 75cm (20 x 30in), acrylic on board

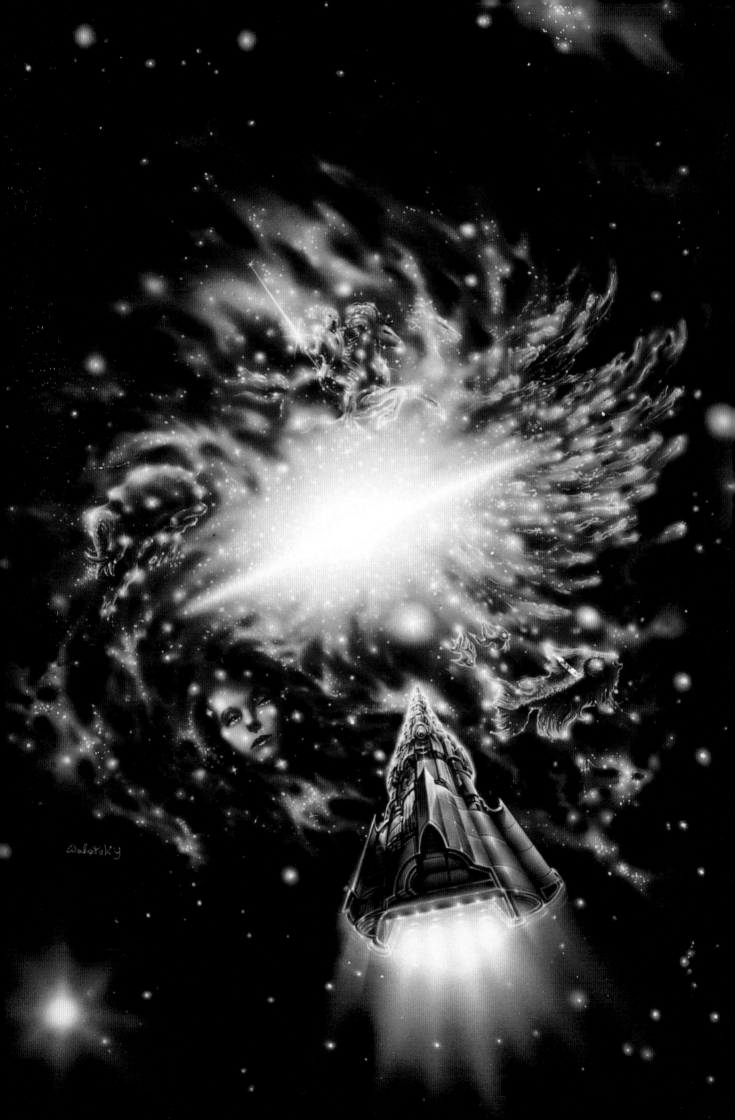

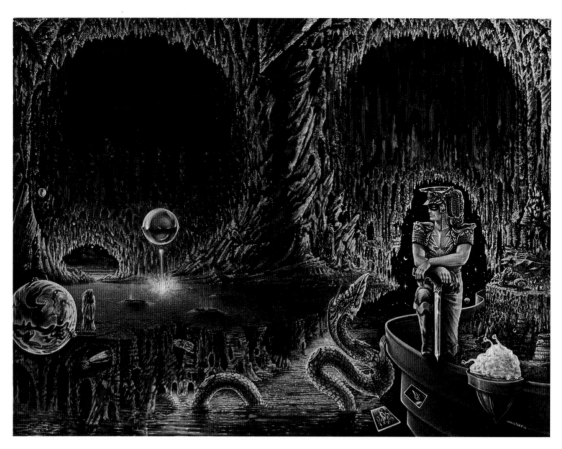

Kirlian Quest
cover for the novel by Piers Anthony, Avon Books, 1978
40 x 50cm (15 x 20in), acrylic on board

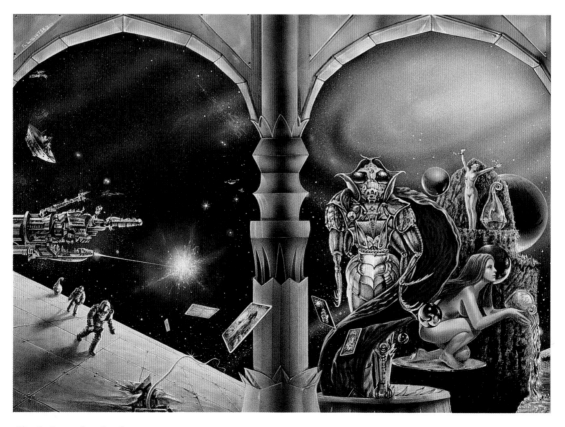

Chaining the Lady
cover for the novel by Piers Anthony, Avon Books, 1978
40 x 50cm (15 x 20in), acrylic on board

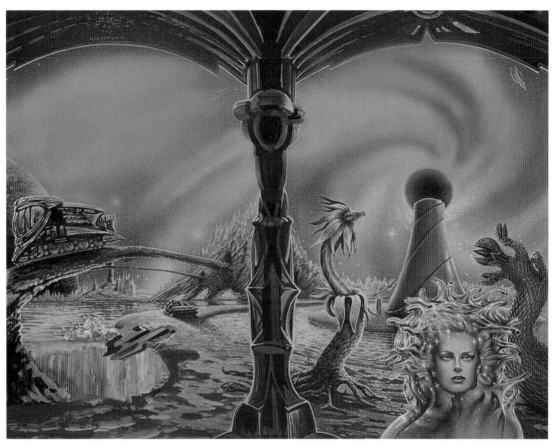

Thousandstar
cover for the novel by Piers Anthony, Avon Books, 1980
40 x 50cm (15 x 20in), acrylic on board

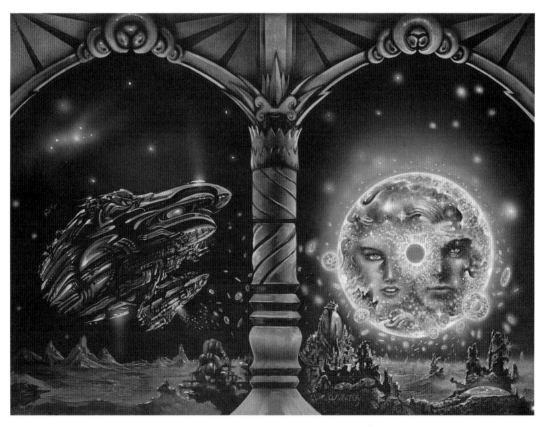

Viscous Circle
cover for the novel by Piers Anthony, Avon Books, 1982
40 x 50cm (15 x 20in), acrylic on board

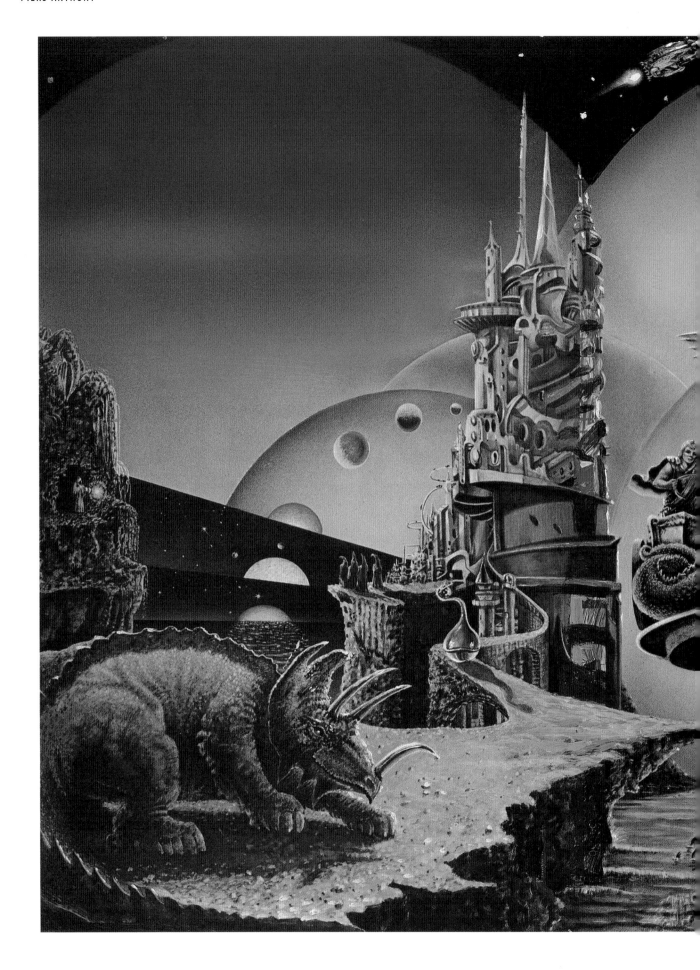

Golem in the Gears
cover for the novel by Piers Anthony, Science Fiction
Book Club, 1986
40 x 50cm (15 x 20in), acrylic on board

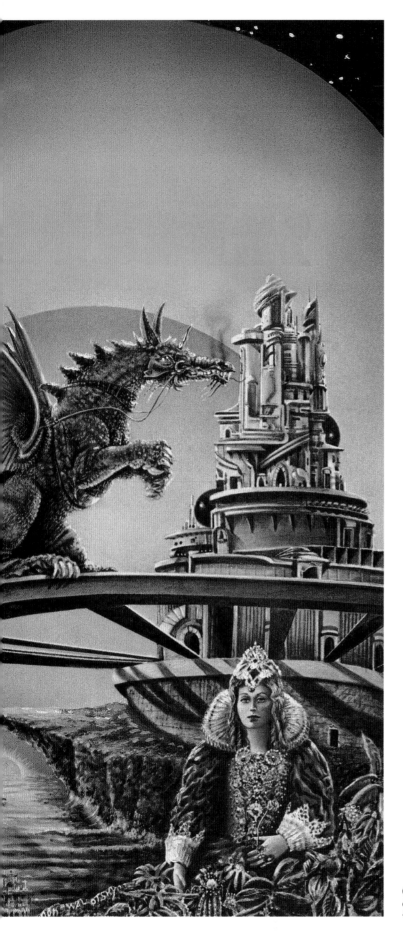

Cluster
cover for the novel by Piers Anthony, Avon Books, 1977
40 x 50cm (15 x 20in), acrylic on board

ROGER ZELAZNY

Barbara Bertoli, Art Director at Avon Books during the late 1960s and the 1970s, commissioned me to paint quite a number of covers for her company. In the usual way of publishing, some of the books were good and some of them were not so good. But when she handed me the manuscript of Lord of Light by Roger Zelazny I knew immediately that this was something special. The writing was strong, but more than that it was the content that blew me away. Events in the novel contribute to the making of myth in a larger context, both within the novel and beyond it. The major characters are in essence Hindu gods and they are engaged in creating their own mythos. Of course, this notion of creating myth from scratch was powerfully pervasive in 1968, when television and media hype were becoming major mythopoeic forces in America.

Barbara said she wanted something different, not "just another cover". We came up with the idea of spot paintings on a black background, and we used this concept for all the covers I did for Roger at Avon, including the books in the "Amber" series, Creatures of Light and Darkness and Doorways in the Sand. I sent the original of Lord of Light to Roger because I was so taken with the book.

Facing page:
Donnerjack
title page for a novel by Roger Zelazny and Jane Lindskold, Easton Press, 1997
50 x 75cm (20 x 30in), acrylic on board

Lord of Light was my first cover for Zelazny and 30 years later I was commissioned to produce this illustration for the last book he wrote. Indeed, the image of Death was so strong in this story that I had little choice of painting anything else, so here's Death with his junkyard dog, monkey and black butterfly. I hope the painting is seen as a fitting end to a long and fruitful collaboration. After Zelazny's death I received a letter from Jane Lindskold, his co-author, saying how much he'd appreciated my painting for Donnerjack.

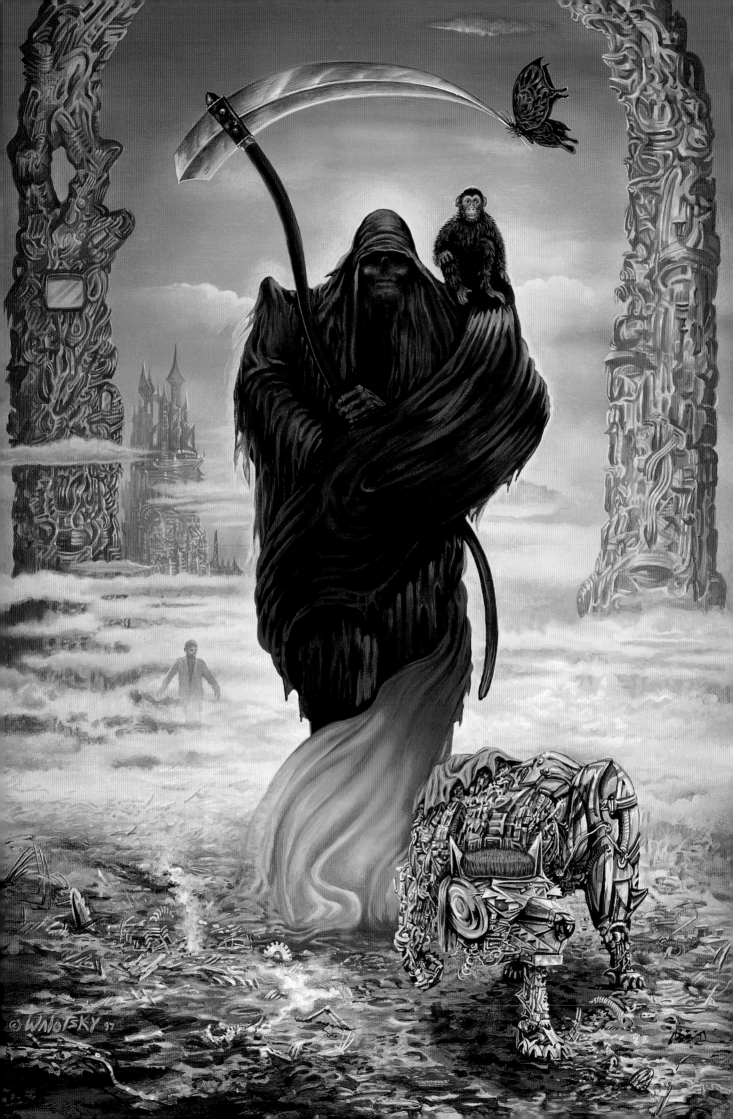

Top:
The Guns of Avalon
cover for the novel by Roger Zelazny, Avon Books, 1976
25 x 35cm (11 x 14in), acrylic on board

Above:
The Hand of Oberon
cover for the novel by Roger Zelazny, Avon Books, 1977
25 x 35cm (11 x 14in), acrylic on board

Top:
Sign of the Unicorn
cover for the novel by Roger Zelazny, Avon Books, 1976
25 x 35cm (11 x 14in), acrylic on board

Above:
Nine Princes in Amber
cover for the novel by Roger Zelazny, Avon Books, 1977
25 x 35cm (11 x 14in), acrylic on board

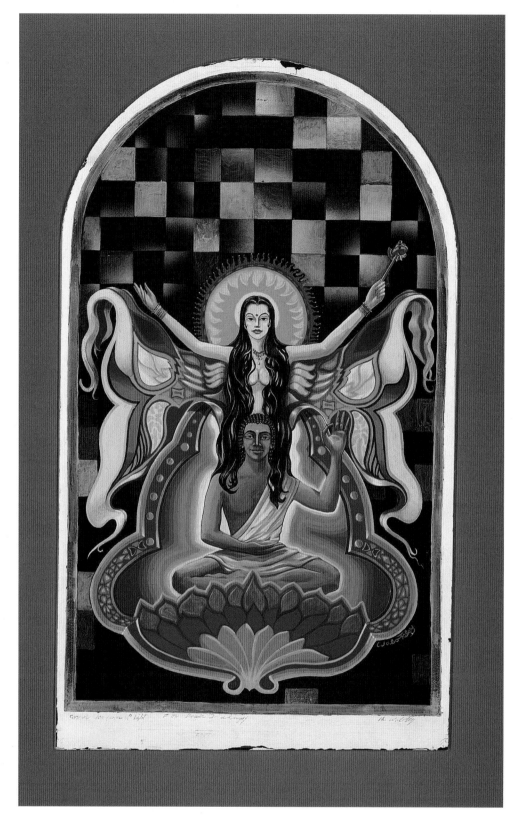

Lord of Light
cover for the novel by Roger Zelazny, Avon Books, 1969
40 x 50cm (15 x 20in), acrylic on board

*Avon used this same cover illustration on the novel from 1969 until 1985,
which I took to be something of a compliment.*

Facing page:
Nine Princes in Amber
title page for a novel by Roger Zelazny, Easton Press, 1996
50 x 75cm (20 x 30in), acrylic on board

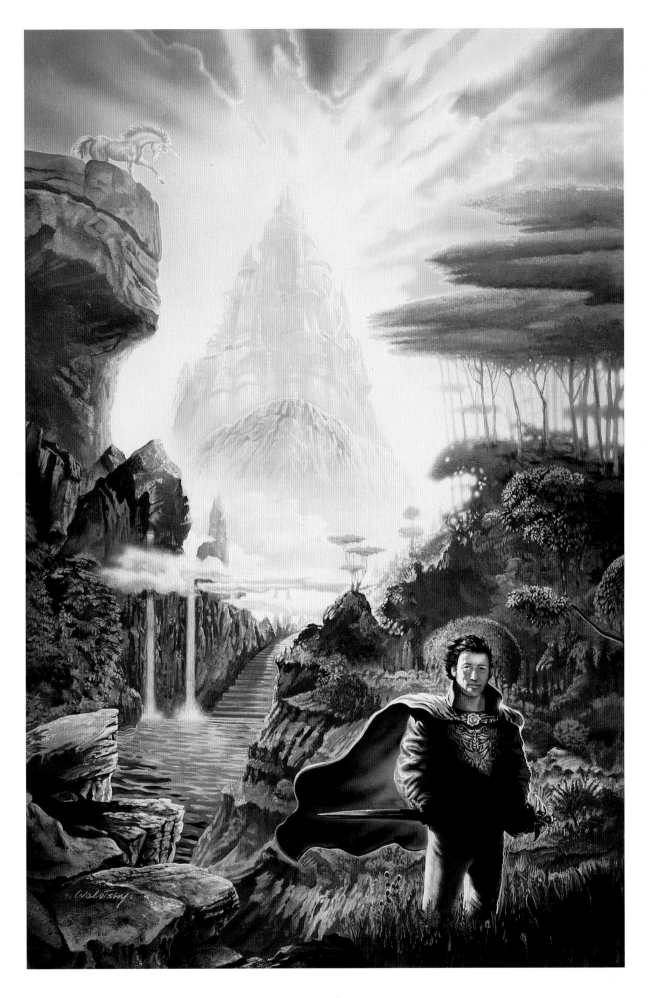

BEYOND THE FAR HORIZONS

What's great about painting science fiction is that you can create your own universes and galaxies. I've never thought of myself as an astronomical artist. I take the reality and twist it, change it, move it into another dimension . . . I make the paintings sing with an alien song. I also try to do hardware that no one has seen yet, that bends the laws of nature.

When I'm painting sf I use the book as a jumping-off point: although I try to stay true to the material, I also always want to put my own flair into it.

Facing page:
2001: A Space Odyssey
cover for the novel by Arthur C. Clarke, G.K. Hall, 1994
40 x 50cm (15 x 20in), acrylic on board

This cover was for the 25th anniversary edition of this famous novel. I'm always honoured to get a commission like this – to interpret a story that has been in the public consciousness for years and years. I wanted to capture the essence of the story through its key element: the smallness of humankind contrasted with the vastness of the universe. HAL's in there, too, at the lower left-hand corner. I had a peculiar experience with this cover. Throughout the period I was working on it, every time I turned on the television the first thing I saw seemed to be the face of Dave – part of the scene I was painting at that very moment! Uncanny.

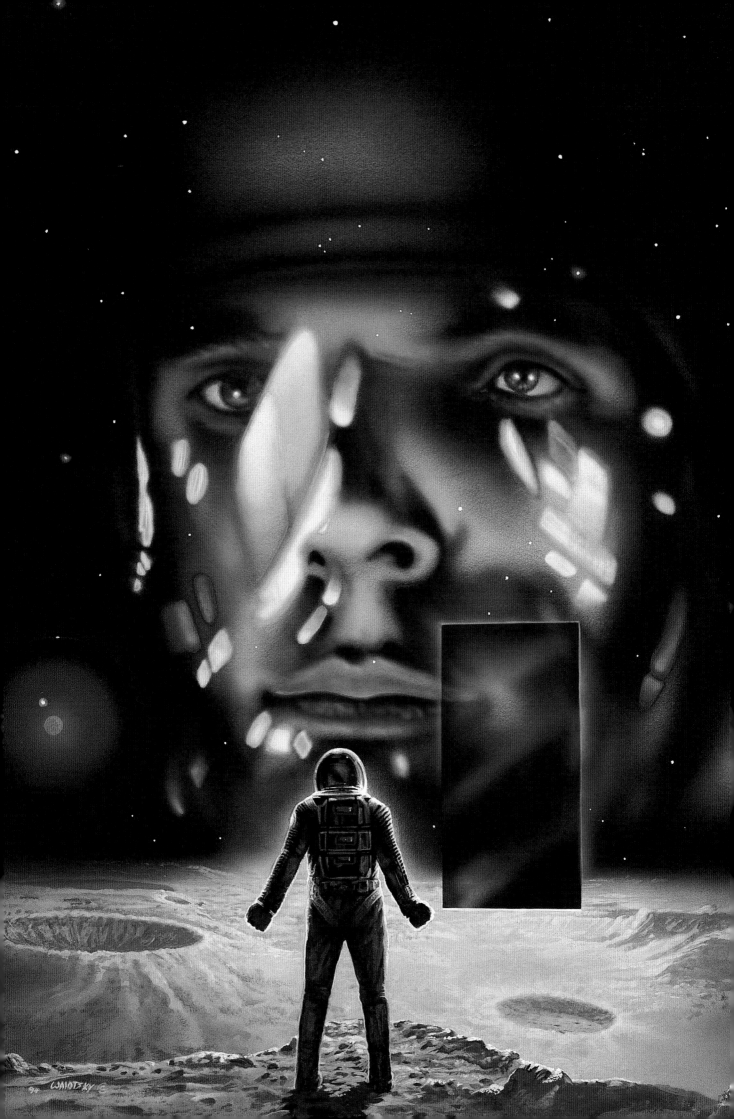

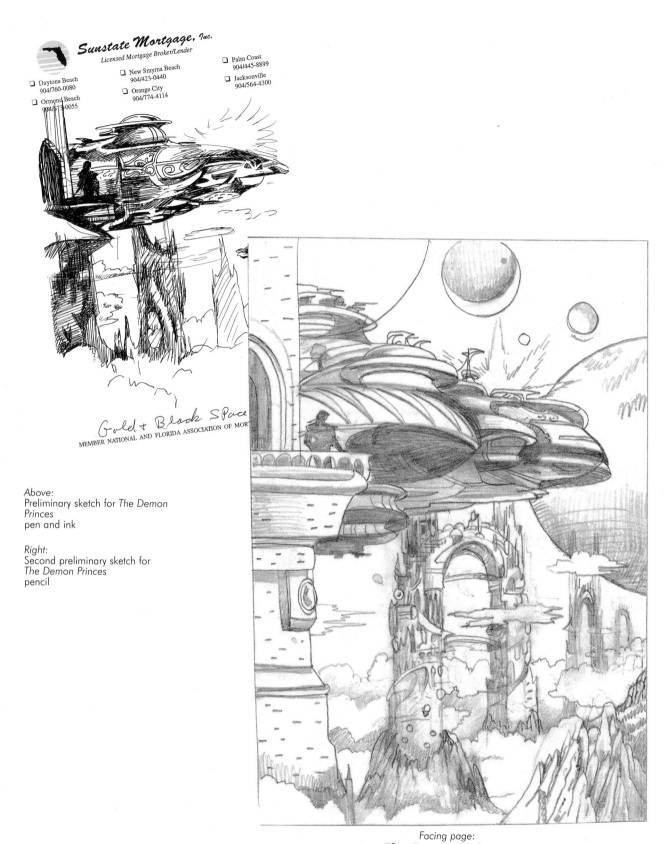

Above:
Preliminary sketch for *The Demon Princes*
pen and ink

Right:
Second preliminary sketch for
The Demon Princes
pencil

Facing page:
The Demon Princes
cover for the omnibus by Jack Vance, Science Fiction
Book Club, 1998
50 x 75cm (20 x 30in), acrylic on board

*In this painting I tried to convey a deep atmosphere by having the ship flow past the
castle in slow motion. I wanted to move you, the viewer, back into the distance,
so that you saw first the figure on the balcony, then the ship, then the castle
on the rocks fading into the haze . . .*

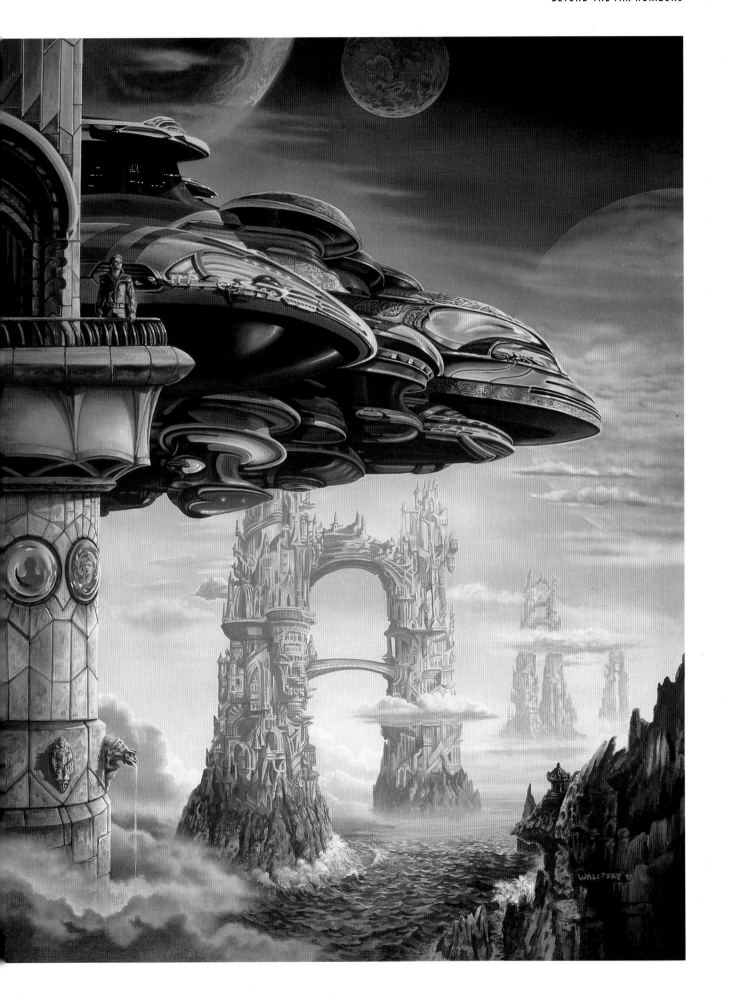

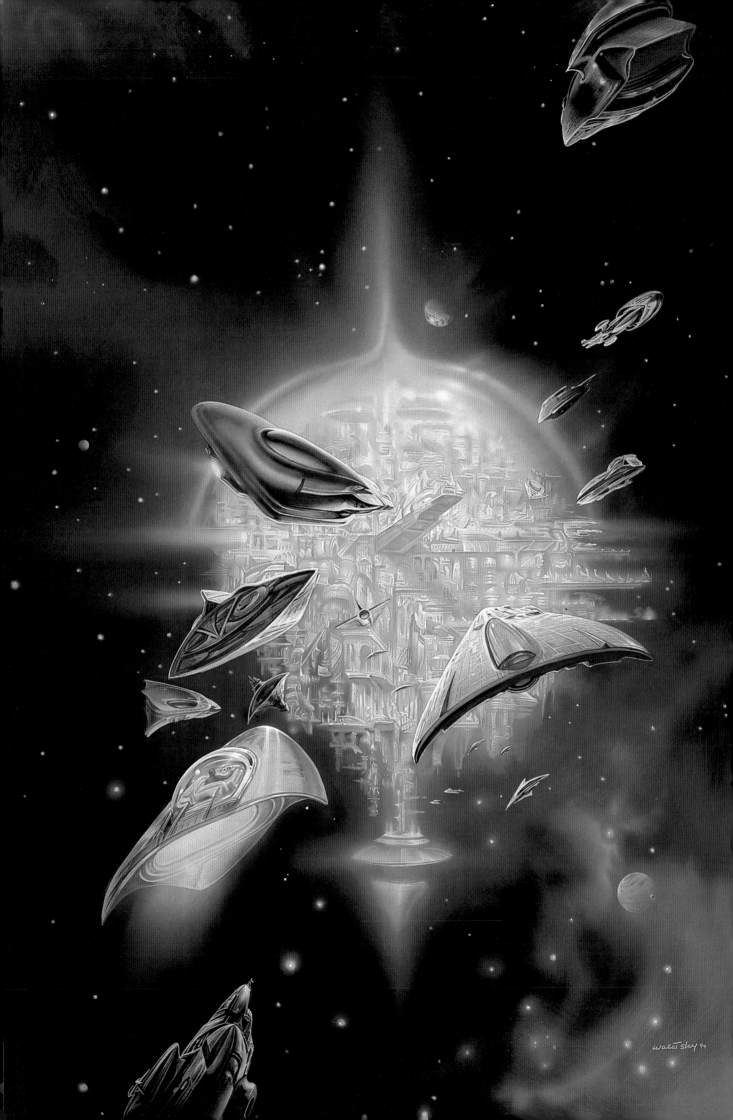

Facing page:
Primary Inversion
cover for the novel by Catherine Asaro, Tor, 1995
50 x 75cm (20 x 30in), acrylic on board

One of my favourite sf covers. Having all the ships moving towards the space station creates a feeling of the structure's immense scale. The image of the ships floating in the blue field and the shape of the space station in fact derive from the horseshoe crab shells that I paint (see pages 106–107). It's amazing how one piece of work can affect an entirely different one! I always like to take disparate objects and try to use them in new and unique ways, looking at something and seeing how I can transform it into something unexpectedly different – like Picasso taking a bicycle seat and handlebars and making a bull's head out of them. Such transformations fascinate me, and I feel that the approach keeps my sf art fresh.

Below:
Earth Ship and Star Song
cover for the novel by Ethan Shedley, Viking, 1979
40 x 50cm (15 x 20in), acrylic on board

In this novel it was the birds painted on the spaceship that grabbed my attention, so that's what I concentrated on. A different artist might have been attracted by something else and so produced an utterly different illustration. I remember once at a science fiction convention where Ray Bradbury was Guest of Honour a group of five of us artists was asked to read a story of his and then produce a quick illustration for it in an hour. It was fascinating to see how disparate the resulting images were: either we chose different scenes or, if we pick the same scene, then we saw it with completely different points of emphasis.

Playful Synergies

"It's not Art – it's just Illustration" . . . one of those supposed truisms which crop up in the amused/cantankerous exchanges between those of us who would wield the brush for a living.

Studying the body of work we might loosely call "fantastic art" it seems to me that there are works out there by ostensibly commercial illustrators, but in which the rigour of the deeply personal creative process is quite manifest. They are often unsung heroes who deserve recognition beyond the claustrophobic confines of the world of science fiction/fantasy. Compare it to the stultifying banality often to be found in the field of supposed "fine art" – some of it not fit to grace the covers of the meanest of commercial output, leave alone the walls of an art gallery!

Sitting amused and beatific amongst all this froth and bubble is the magnificent Ron Walotsky. Ron cleverly evokes the mood of an earlier "golden" age of sf complete with its spooky, unreal lighting, its subtly hinted paranoia, its mysterious rather than overt, in-your-face evocations of the alien. Looking at Ron's purely science fiction output I get the same frisson of pleasure that picking up an old classic by van Vogt or Heinlein gives me. This nostalgic/spooky evocation of a golden age is a damned clever trick! The subtle lighting and colour that shifts us a sidestep from reality suggests parallel universes and alternative histories – part of the essential stuff of science fiction. These paintings also possess an unnerving, dream-like quality. With this trick Ron manages to imbue his work with the essence of Surrealism, that eccentric off-shoot of the mainstream which used the stuff of dreams and

the unconscious as its primary source of inspiration. Little homages here and there to Ernst, Dali and Magritte. More strongly, the playful influences of Miró and Tanguy.

Where Ron Walotsky differs most from his illustrator contemporaries is in his ability to dip into myriad references from late nineteenth- and twentieth-century art. It suggests an unusual depth of knowledge of his subject and certainly, on the few times I've met Ron, his demeanour comes over more as that of a man deeply involved with the serious creative process than with the facile business of "book jacket art".

It's an amusing diversion to play "spot the homage" with Ron's work! Over here we will find a nod in the direction of Redon (the Symbolist credo being one to which Ron would surely subscribe), over there, particularly in Ron's more Expressionist paintings, a glimpse perhaps of Le Douanier Rousseau?

There is a quintessentially American mood to a great deal of Ron's work too, particularly his more personal, abstract work. Pure Ron Walotsky but imbued with the spirit of those who have gone before, a fascinating synergistic process that cleverly conjures up Rothko in some compositional device, O'Keefe in a particular detail or the essence of Rauschenberg in a paint stroke.

Ron's work is strange and evocative, but it is also immensely accessible. I'm so glad this artist – who could have turned his creative hand towards almost any branch of the visual arts – has chosen in large part to express himself within the commercial arena. He occupies his own singular niche in our rather introspective world of fantastic art. With his playfulness, his honouring of valued traditions and his deep knowledge of the wider field of Art, he manages to haul our beloved genre away somewhat from its occasional navel-gazing tendencies and transforms it into a bigger, more generous thing altogether.

Jim Burns

Left:
The AI War
cover for the novel by Stephen Ames Berry, Tor, 1987
50 x 75cm (20 x 30in), acrylic on board

Quite a few of the spacescape covers I've done for Tor have been of ships floating in space, but for this one they wanted a bit more action. Generally I prefer more meditative spacescapes, but actually I was pretty cheered by the way this picture came out – lots of action as the space battle rages. It makes them much more interesting to me – and hopefully to the viewer as well – because I don't have to stay within the borders imposed by the limitations of human design preconcept.

Facing page:
Prometheans
cover for the story collection by Ben Bova, Tor, 1986
50 x 75cm (20 x 30in), acrylic on board

I wanted this to be an alien spaceship. I didn't want it to look anything like the human spaceships we've seen since childhood in illustrations or, latterly, in real life. I wanted viewers to have the feeling they were looking at something they'd never seen before. So I tried to make both the design of the spaceship and the materials of which it was made look like they might from an alien world. I try to do this in general with alien artefacts such as spaceships.

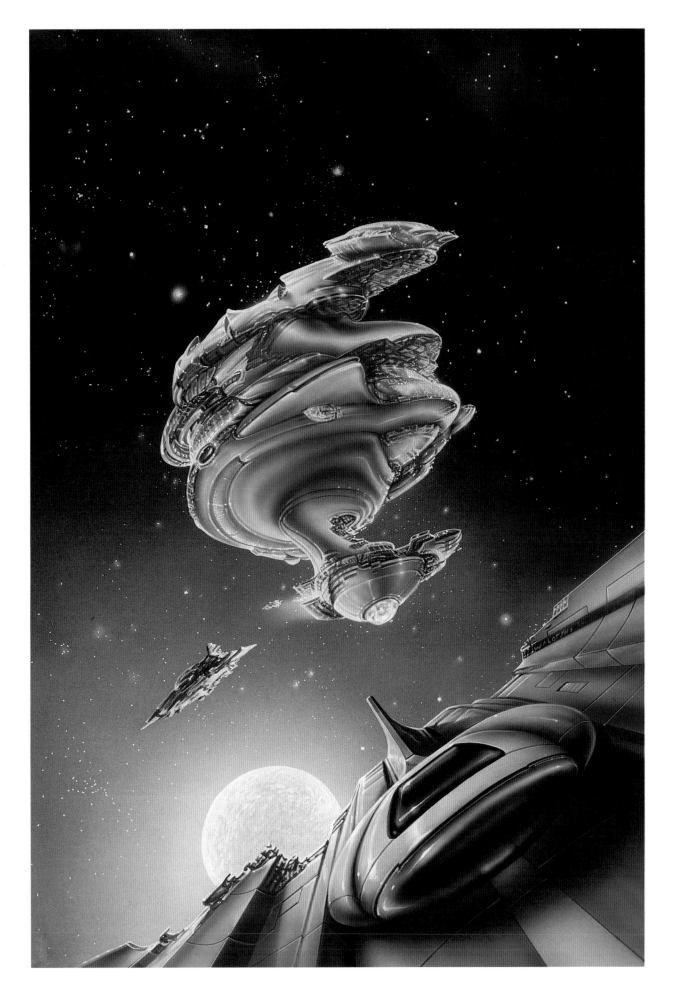

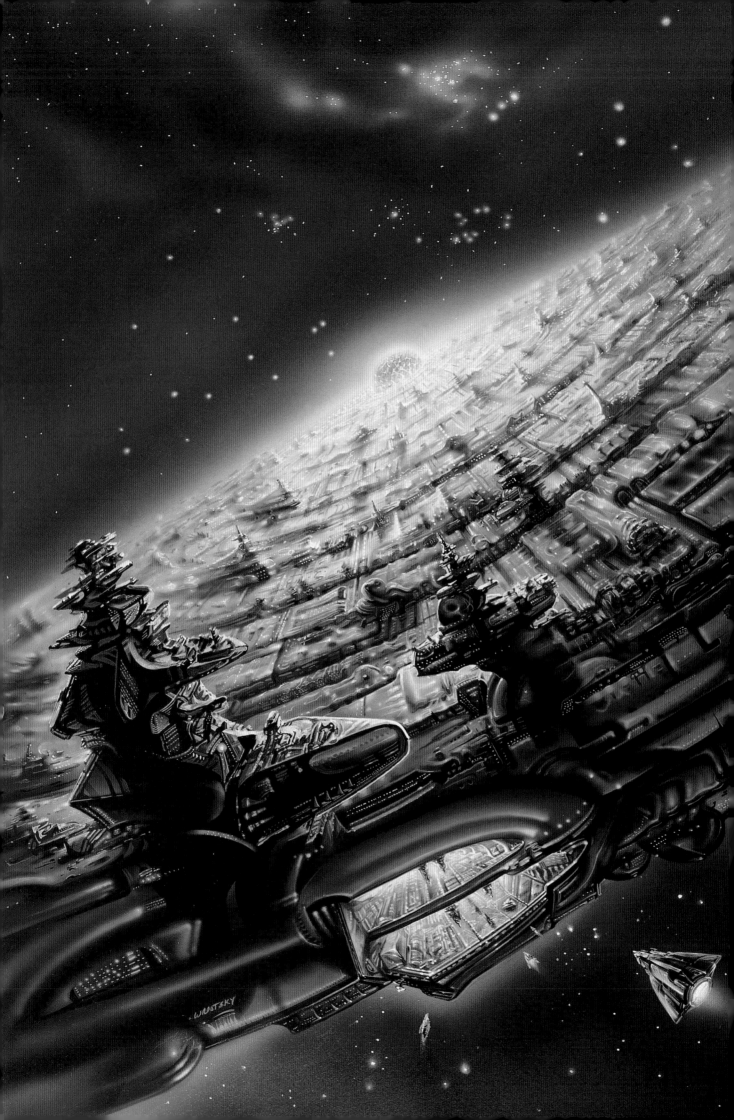

Epiphany of the Long Sun
cover for the omnibus by Gene Wolfe, Science Fiction Book Club, 1996
50 x 75cm (20 x 30in), acrylic on board

Gene Wolfe writes great visual images. The idea in this novel (and in its companion novels) is that the characters have spent all their lives inside a gigantic spaceship and have no idea they're not living on a planet. I tried to create an almost operatic sense of scale in this picture, so that, as you move back through the villages into the distant space of the ship, you feel that you're encompassing a thousand miles or more . . .

Facing page:
The Architects of Hyperspace
cover for the novel by Thomas R. McDonough, Avon Books, 1987
50 x 75cm (20 x 30in), acrylic on board

The book features a space station the size of a planet which rotates around a central core. I wanted to catch the feeling of both the impressive size and the rapid rotation, so I made parts of the picture a little blurred.

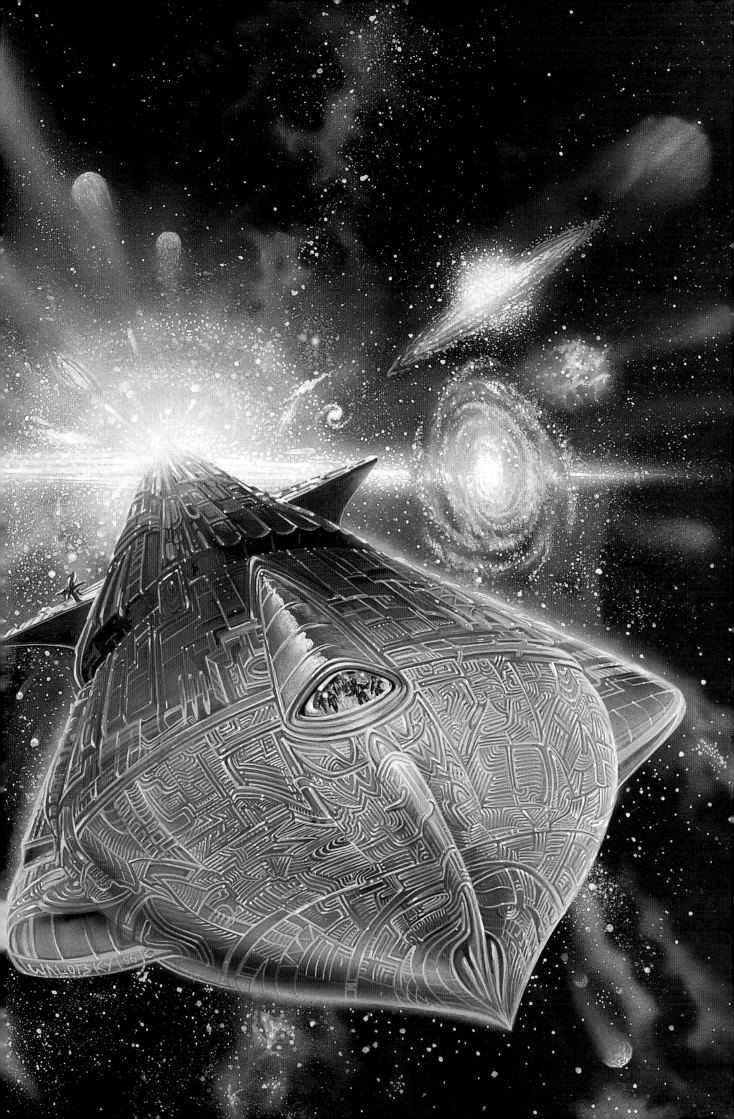

Previous pages:
Tau Zero
cover for the novel by Poul Anderson, Science Fiction Book Club, 1997
50 x 75cm (20 x 30in), acrylic on board

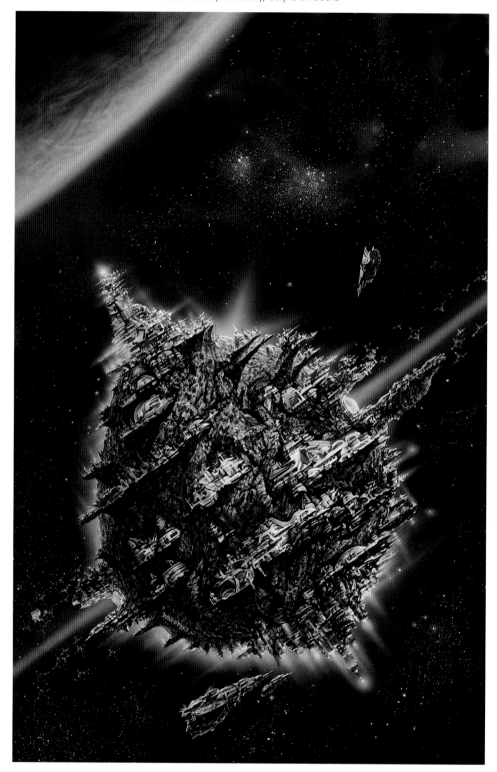

Final Assault
cover for the novel by Steven Ames Berry, Tor, 1988
50 x 75cm (20 x 30in), acrylic on board

Facing page:
Clouds of Magellan
cover for the novel by David F. Nighbert, St Martin's Press, 1991
40 x 50cm (15 x 20in), acrylic on board

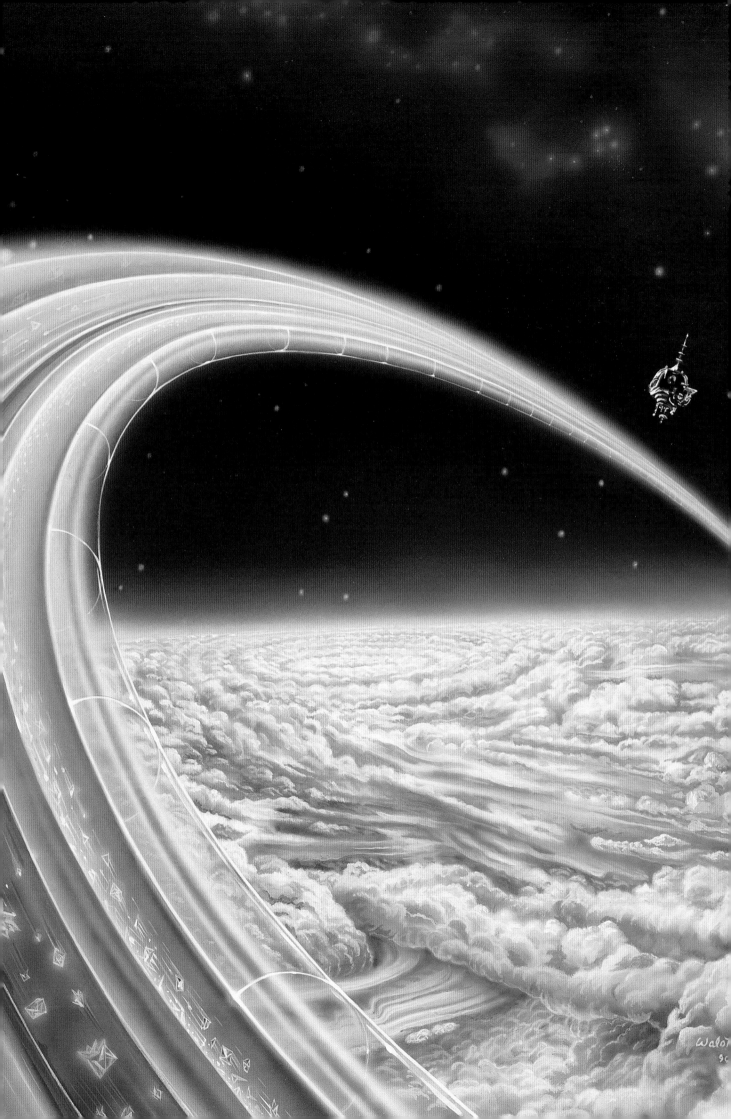

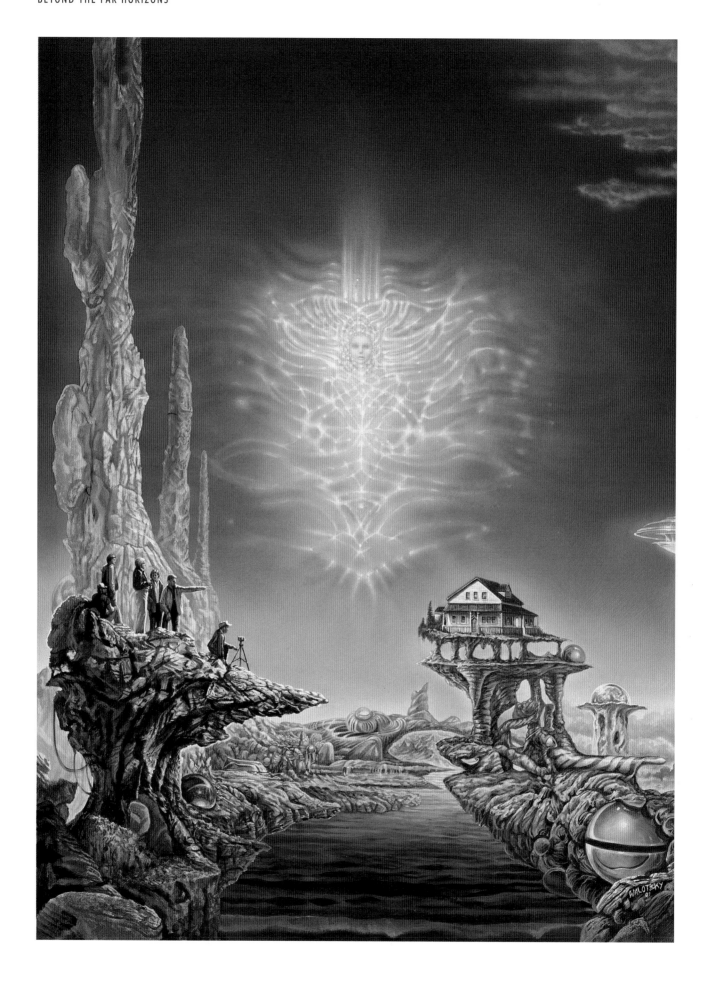

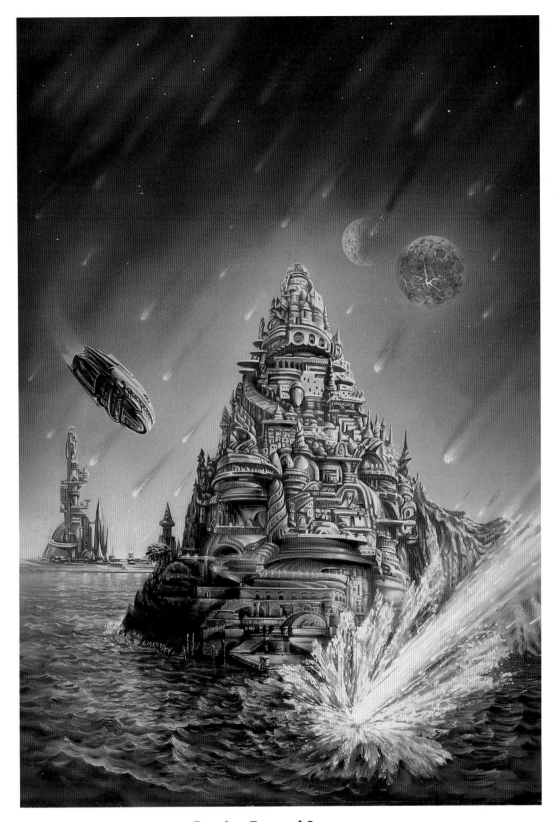

Burning Tears of Sassurum
cover for the novel by Sharon Baker, Avon Books, 1988
45 x 60cm (18 x 24in), acrylic on board

*The cities of fantasy fiction are a joy to paint – steeping myself in the architecture and forms, the shadows and light,
and creating the images with colour and shape, sometimes just by a slash of paint.*

Facing page:
Cosmic Tourist
cover for *Amazing Stories*, November 1991
42 x 55cm (16 x 22in), acrylic on board

*For once I wasn't given a specific story to illustrate, just told to come up with my own idea for the cover. I chose a few
aliens and some humans visiting a surrealist landscape – the question is: who are the tourists, the aliens or the humans?*

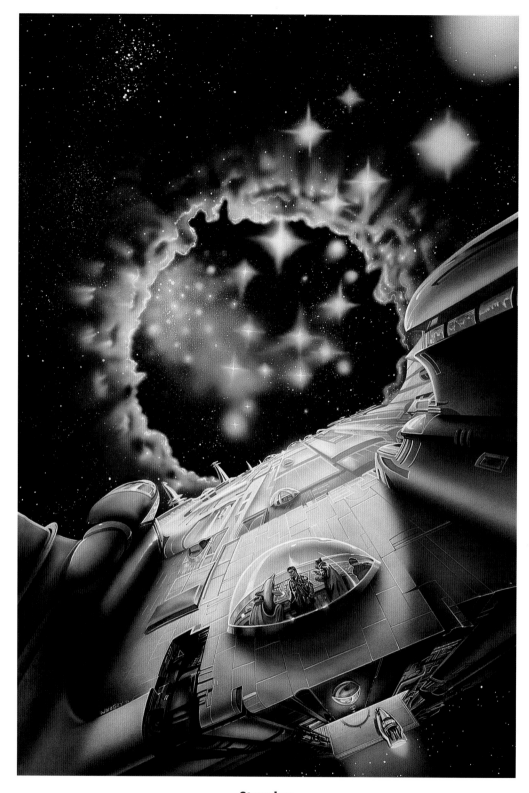

Starplex
cover for the novel by Robert S. Sawyer, Science Fiction Book Club, 1997
50 x 75cm (20 x 30in), acrylic on board

Facing page:
Destiny's End
cover for the novel by Tim Sullivan, Avon Books, 1988
50 x 75cm (20 x 30in), acrylic on board

How could I make a painting of a lone spaceman seem new and fresh? The subject's been done a thousand times. Like many other artists before and since, I tried to come up with something different. When you first glance at the picture everything seems OK – but as you look at it longer you discover the reality is impossible. Check out the horizon line, and then the figure – no, it's not feasible to stand like that. The idea was to have something that appeared superficially normal but, the closer you looked, more of its strangeness was revealed.

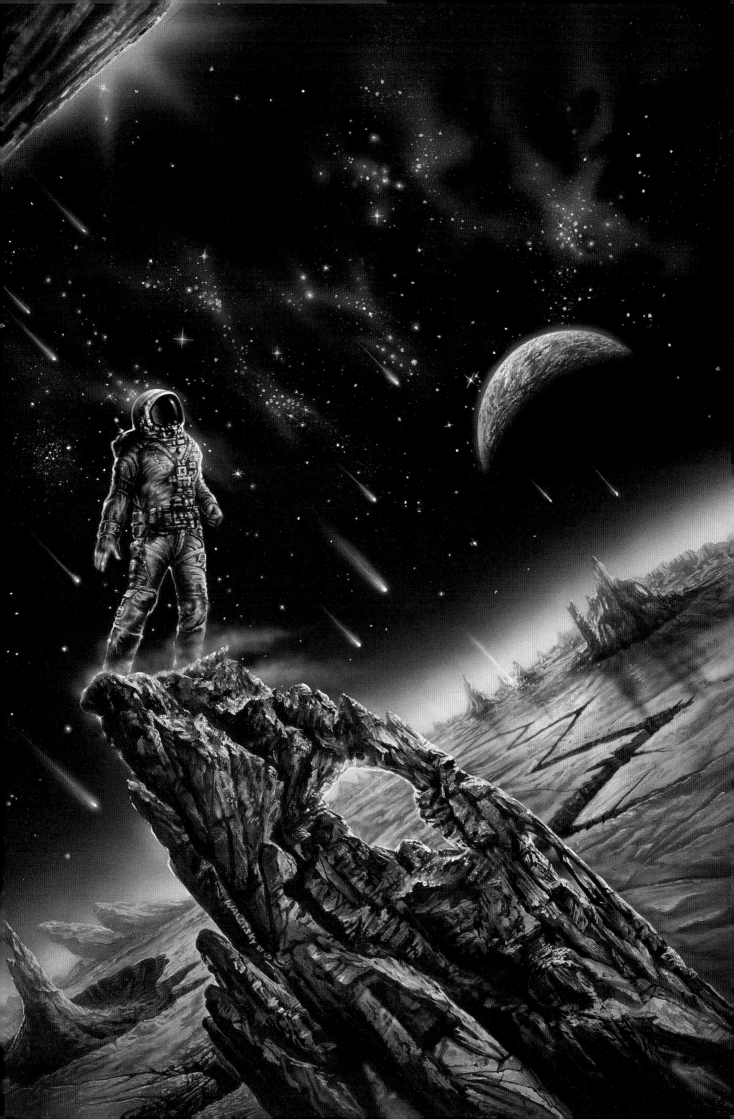

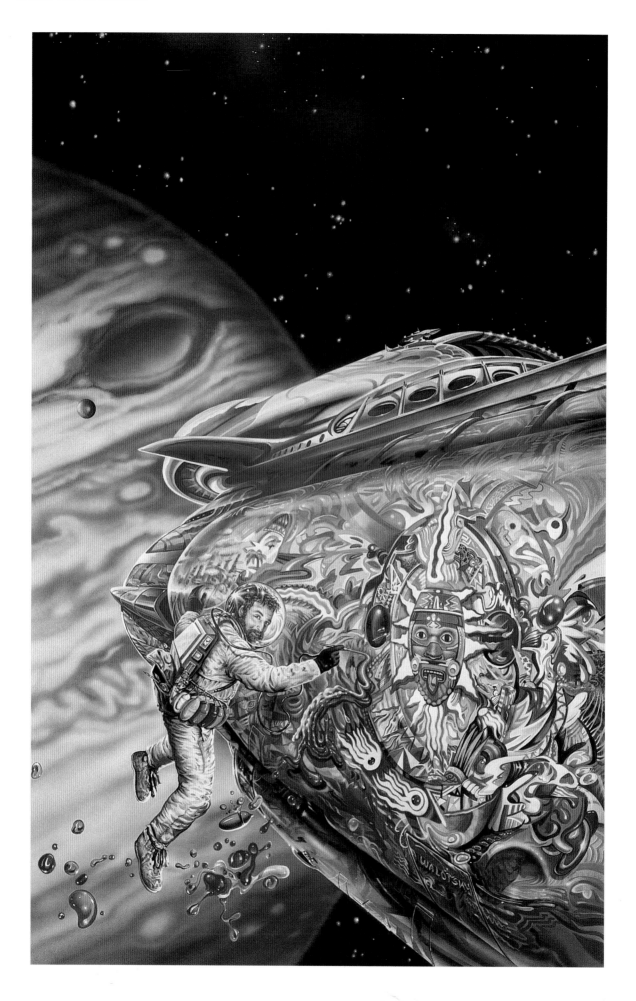

Facing page:
Cortez on Jupiter
cover for the novel by Ernest Hogan, Tor, 1990
50 x 75cm (20 x 30in), acrylic on board

This novel has a graffiti artist as its main character, and one of the scenarios was of him painting the side of a rocket. I loved the idea! I had a friend pose for Cortez, wearing a silver jogging suit. I then decided to have him daubing a group of Mayan symbols on the side of the rocket, and after I'd finished this painting the image of his daub stayed with me: I kept thinking it'd make an interesting picture in its own right. In the end I succumbed and produced a painting called Mayan Myth.

Below:
Mayan Myth
interior for *Amazing Stories*, July 1992
110 x 110cm (44 x 44in), acrylic on canvas

I showed this painting to the people at Amazing, and they were sufficiently intrigued by it to want to use it. This is one of the few times they've asked someone to write a story to go with a painting instead of the other way round.

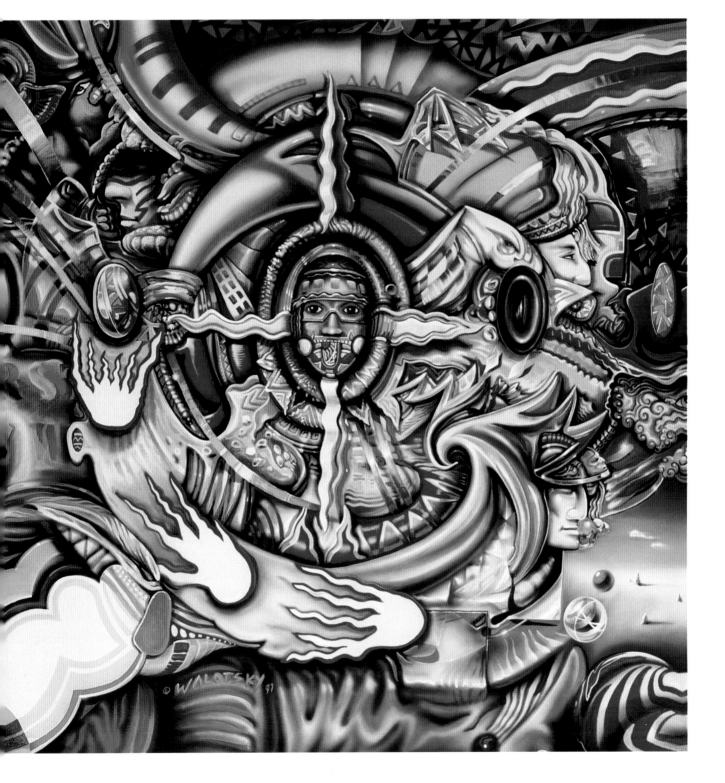

A Word About Ron . . .

When Ron Walotsky asked me to write something for this book, I shuddered slightly – one of the reasons I became an editor was so I wouldn't have to write. But hey, he's a great guy and a terrific artist (not to mention a friend of long standing), so I had to say yes.

He's been creating wonderful art for the Science Fiction Book Club for two decades now – over 40 book jackets, plus I don't know how many pieces for the club magazine and various bits of advertising. Some of it's on my wall at home, which is the best way to look at it – but at least, reprinted in book form, the rest of the world can enjoy these artworks long after the books have gone out of print.

What is it that makes his work so special? For me, at least, it perfectly captures that sense of the rich and strange that first drew me to science fiction. His baroque alien landscapes could never be mistaken for anything earthly; his strangely organic spaceships are not confined by NASA's parameters. The worlds he paints manage somehow to be true to the vision of the author of the book that inspired them while still remaining uniquely his own.

I can't wait to see what he does next.

Ellen Asher

Above:
Perpetuity Blues
cover for the novel by Neil Barrett Jr, Golden Gryphon Press, awaiting publication
50 x 75cm (20 x 30in), acrylic on board

Although this story takes place on Earth, its atmosphere calls for something different. It's about a girl coming of age through hardships and traumas, and about a strange fellow who always seems to be there for her. The scene in the painting isn't drawn from any specific event in the book, but it has the right feeling. This book was to have been published in early 2000 by Golden Gryphon Press, but to our shock and dismay, the publisher, Jim Turner, recently died. At the time of writing, I don't know what the painting's status is.

Facing page:
Return to Mars
title page for a novel by Ben Bova, Easton Press, 1999
50 x 70cm (20 x 28in), acrylic on board

Easton Press sent me the full manuscript, and the story held my interest right to the end. One advantage of doing title pages for this publisher is that you have the whole page to work with: no type to worry about. Ben Bova is one of those sf writers whose work is always rooted in reality, and so in the picture I tried to keep things as realistic as possible while giving the illustration the sense of scale that the dramatic Martian landscape demands – with the huge canyons and particularly the towering Mons Olympus, a volcano the size of the state of Idaho!

Aliens Turn Victim Into Science Fiction Artist!!!

Noted book illustrator Ron Walotsky reveals in a shocking interview how aliens from a distant galaxy performed brain-control experiments on his head and body. The result has turned a well-behaved individual into a rampant artist. In a candid report to an inquisitive colleague, Walotsky admitted to neuro-kinetic impulses which travel light years across space to implanted invisible receivers left by aliens in the right side of his brain.

This reporter has suspected strange forces at work since his first meeting with Ron Walotsky at Noreascon Science Fiction Convention in Boston. He (Walotsky) seemed too cheerful and relaxed. His confident and well-mannered personality had to be a ruse of some kind, because the paintings produced by this artist are too unique, well conceived and competently executed to have come from an ordinary earthly intelligence.

Works exhibited by Mr Walotsky show an almost first-hand knowledge of space travel, alien life forms and realms deep beyond the visible world: the astral and metaphysical planes. There is a sense of enlightened imagination coupled with convincing believability exhibited in his images. The incongruity of Walotsky's apparently easy-going nature, coupled with what seems like supernatural talents and a complete knowledge of all the workings of the universe as yet undiscovered by science, has led this reporter to pry into the artist's past.

Walotsky has produced an enormous and varied body of work, including the most famed Roger Zelazny's "Amber" series covers, to Piers Anthony, to sf for Robert Silverberg books. Such virtuosity in itself

seemed suspicious, and led this reporter to delve deeper into the story of Walotsky's career.

It quickly became apparent that Ron tried to hide his mind contact with the extraterrestrials by doing work that one would not normally suspect him of. Besides his book covers within the sf field, Walotsky has provided artwork that was designed into apparel, artwork that became a backdrop for a Billy Joel video, not to mention album covers, art for the *New York Times* Sunday edition and *Penthouse* magazine and covers for Norman Mailer's *The Presidential Papers*. In a brilliant move to integrate his acquired talent upon the unsuspecting world, he had a one-man exhibit in SoHo. This show consisted of many large interpretive abstracts that, although different from his illustration work, still could not disguise the alien creativity that guides this artist's inspiration.

For, if one looks into Walotsky's past, it is apparent that he had an ordinary boyhood. Born in Brooklyn, raised in Ohio and then brought back to Brooklyn by his truck-driving mom, he admits he wasn't an outstanding student. He then enjoyed a very normal education at the School of Visual Arts in New York.

But, after he gave up a promising career in advertising, neighbours began to report strange noises and queer lights in the vicinity of Walotsky's studio. These unbiased testimonies established the truth of Ron's admission of strange dreams involving flashing spectrums and gnarly creatures with powerful hypnotransducers which caused his mind to become a receptor of images from other universes.

That Walotsky has made a success of his communication with alien life is an established fact. The particulars of his technique were revealed when this reporter tracked the artist home to his beachside house in Florida and watched through the studio window. On assignment, Ron is seen to read entire manuscripts at a glance, in an unblinking stare. Next he tilts his head as if listening; then, his airbrush compressor turns on automatically! Pencils levitate fluidly to his hand, and they glow purple and green at his touch! He looks down at the graphite, and beams of light like lasers burn the point to surgical sharpness in a microsecond! Then, with robot-like precision, his illustration board begins to receive the intricate layers of pigment that have become the envy of his peers.

Late, late into the night, the airbrush compressor stops by itself. The obsessed look fades from Walotsky's stare. Slowly he rubs his eyes and turns away to retire. In the morning, coffee cup in hand, he enters the studio – shock and surprise cross his face as he sees what he has created under the influence of alien impulses.

Some might suggest that this report is laced with exaggerated, unsubstantiated rumour – and, yes, the facts may be hard to believe and to corroborate. But no right-thinking sf fan who takes time to look at Ron Walotsky's paintings can deny they are singularly and uniquely otherworldly.

Don Maitz

8

VINYL DREAMS

Back in the days when there were albums, my child . . . You don't believe there ever were such things? Well, it's true — not just a myth or legend. There was this really marvellous format people asked you to paint in: a square. You didn't have to worry too much about leaving the top one-third of the painting bland for the lettering, and you knew that your art would be reproduced nice and big — twelve inches square, in fact. I've done a few rock albums — for Rainbow, Cameo, Jefferson Starship, and others — but what I loved were the classical albums . . . getting a sense of what the music was about, recreating that mood in visual terms, letting my imagination flow with it .

You still don't believe there were ever such things as albums, my child? Well, here are a few album covers to prove what I say . . .

Dido and Aeneas
album cover for RCA Red Seal, 1978
45 x 45cm (18 x 18in), acrylic on board

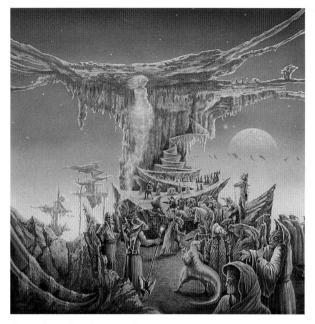

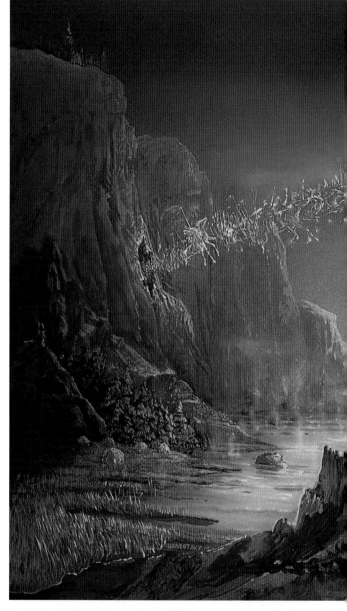

Symphonie Fantastique
album cover, RCA Red Seal, 1974
45 x 45cm (18 x 18in), acrylic on board

Back in the days when albums were, you know, albums I seemed to get a lot of work from RCA doing the covers for classical records. You'd have thought they might have wanted classical images to go with the music, but instead they often preferred surreal ones. Berlioz gave this symphony a programme, an underlying story about a man whose nightmares take him to a witches' ball – great material for me to work with! When you listen to the part where the witches are flying in from all over, it's very easy to conjure up the scene as Berlioz must have envisaged it – or, at least, that's what I told myself. I had tremendous latitude when conceiving the creatures because, of course, there aren't any descriptions in Berlioz's programme notes. I love the sensation of depth and of space that I can convey in this type of painting.

Ruslan and Ludmilla
album cover, RCA Red Seal, c. 1979
45 x 45cm (18 x 18in), acrylic and gold leaf on board

The music was creating a tone picture that could be interpreted and understood in an extremely vivid visual way – a musical portrait of Mother Russia using many different folk melodies as its basis. I chose to be as true to this aim as possible, and this meant creating an image that conveyed the sense of Mother Russia as a land of folklore. Accordingly, I used a style unlike anything I'd ever attempted before, one that approximated as closely as possible to those lacquered boxes that used to be (and for all I know still are being) made in Russia. Even the medium was part of my message: in the same way that many of these boxes used gold leaf, so did I.

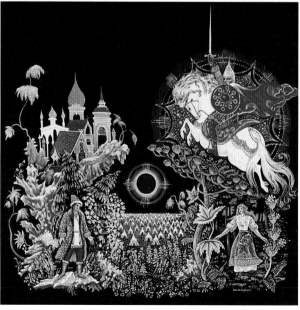

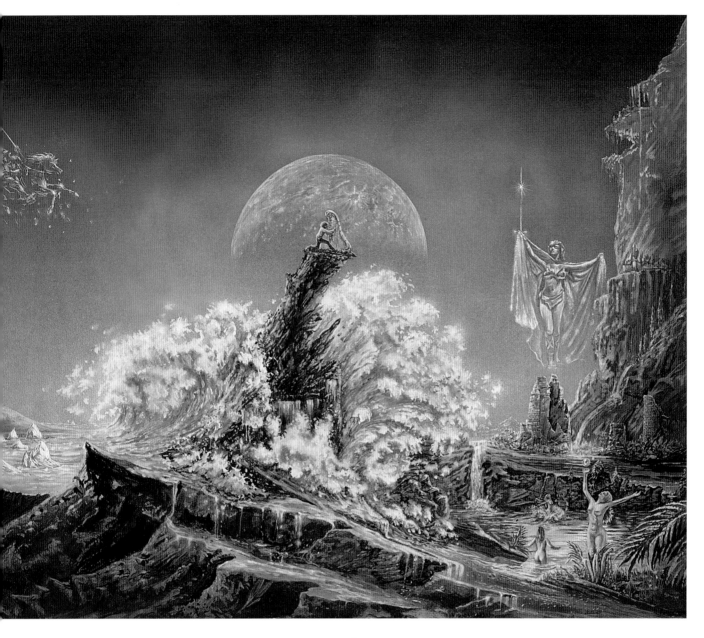

Ma Vlast
album cover for RCA Red Seal, 1979
50 x 75cm (20 x 30in), acrylic on board

UNREALISM – ABSTRACT ART

I've painted abstract art since the beginning of my career. Indeed, abstract art is one of the reasons I became involved in science fiction: I thought doing sf illustrations would be a great way to make a living while I worked on my own paintings. When my values changed a bit, as sf art became more and more important to me, I realized that even though it's very rewarding to illustrate, you still need to paint your own ideas as well.

The early abstract pieces had a strong Eastern feel – very simple, completely unrepresentational. I wanted them to evoke the emotions directly, without any intermediate distraction such as a depiction of reality.

Plains of Sumatra
personal work, 1972
1.5 x 1.5m (5 x 5ft), acrylic on canvas

Clouds
personal work, 1971
1.5 x 1.5m (5 x 5ft), acrylic on canvas

This early work was made up of thin bands of colour that gradated very slightly as they moved through the painting. From a distance they looked almost air-brushed, but in fact they were painstakingly painted by hand. Some of them were pretty big – up to the likes of 1.5 x 1.8m (5 x 6ft).

I painted these for about six years, then moved on. I started to do illusionistic abstract work. I've always enjoyed working with the space of a canvas: having things on different levels, using the paint as forms. I was still applying the same concepts as from my early work, making the placement of colours function as in a Japanese garden – to draw you in, to surprise you, to make you look at the painting and clear your

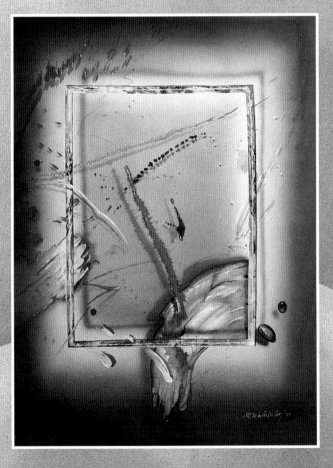

Red Slash
personal work, 1996
60 x 75cm (24 x 30in), acrylic on paper

Afternoon Mood
personal work, 1997
60 x 75cm (24 x 30in), acrylic on paper

mind of everything else. (I've used similar notions in my illustration work.) These paintings are done without initial sketches: I like the spontaneous nature of my work on them, the immediacy. They evolve as I'm creating them; I don't know what the final outcome will be. Although I start off with an idea, it can change as the painting progresses. Sometimes these pictures work wonderfully well, other times they can totally miss the mark.

Working on the abstracts is therefore the very opposite of illustrating, where you have to be very specific and detailed from the start.

Doorways in the Sand
personal work, 1997
60 x 75cm (24 x 30in), acrylic on paper

Silver Frame
personal work, 1986
1.5 x 1.8m (5 x 6ft), acrylic on canvas

THE "CHILDREN" SERIES

This recent series of paintings combines the illusionistic abstract work with a figurative element. Having children moving through the abstract space makes the paintings work on different levels. Children's worlds are basically abstract; by having them moving through this type of a space I'm trying to convey their interactions with the unknown and their apprehensions of what can happen next.

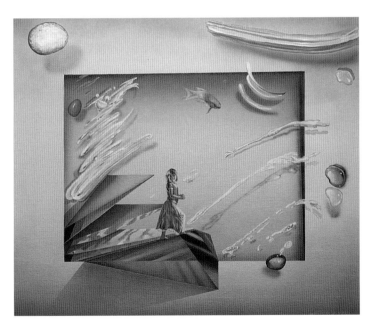

I've Got a Secret
personal work, 1998
50 x 60cm (20 x 24in), acrylic on canvas

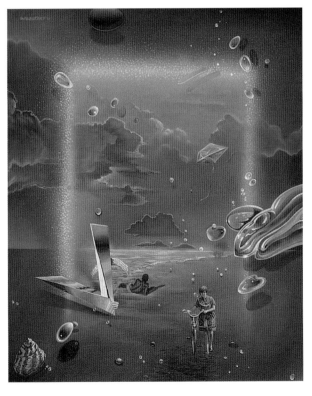

Daydreams
personal work, 1999
50 x 60cm (20 x 24in), acrylic on canvas

Writing in 1998 in the Jacksonville, Florida, newspaper Folio about an exhibition of my paintings in this series, Charlotte Safavi had this to say:

"Three characteristics of Walotsky's work are evident in these pieces: an underlying yet accessible mysticism, a deft handling of colour, and an ability to conjure emotions. Upon closer inspection, Walotsky's children, in their surreal worlds, can be identified with. The roads they travel suggest a pleasant nostalgia, but are also rough, rocky and frightening."

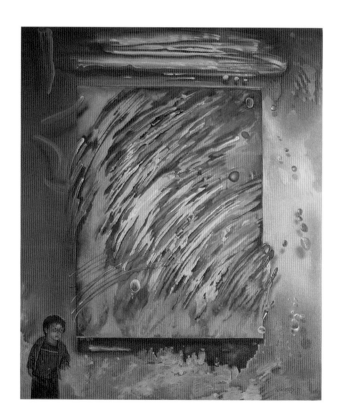

Something in the Air
personal work, 1998
50 x 60cm (20 x 24in), acrylic on canvas

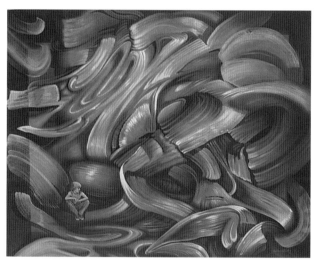

Letting Go
personal work, 1999
60 x 75cm (24 x 30in), acrylic on canvas

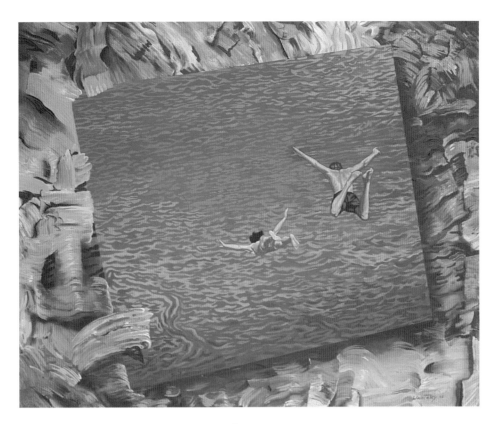

Jump
personal work, 1999
50 x 60cm (20 x 24in), acrylic on canvas

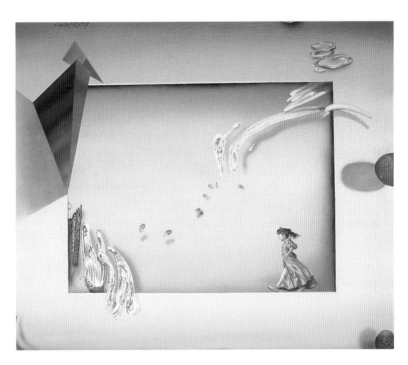

The Sky is Falling
personal work, 1998
50 x 60cm (20 x 24in), acrylic on canvas

ANCIENT WARRIORS FROM LOST CIVILIZATIONS

A few years ago I was living next to the beach in New York. Among my fellow habitués of the beach were all these horseshoe crabs. These creatures moult, leaving their old shells behind. I got into the habit of taking shells and other beachcombings I found back to my home. One day I was looking at one of the shells and the image of a face and helmet just materialized before me. The next morning there were thousands of horseshoe crab shells lying on the beach, and I took this as a sign.

I saw the masks I began to create as representing ancient warriors from lost civilizations, and that's how my eventual collection of them gained its name.

Each of the masks is completely different from any of the others. The only thing I add to the (thoroughly cleaned!) shell is paint. I create the illusion of the faces using just shadow; most of the masks don't have eyes painted in, because this adds to their mystery. I paint them as a shaman would for a ritual or celebration, trying not to impose my own will upon the shell: I let the "warrior" dictate what it's going to become.

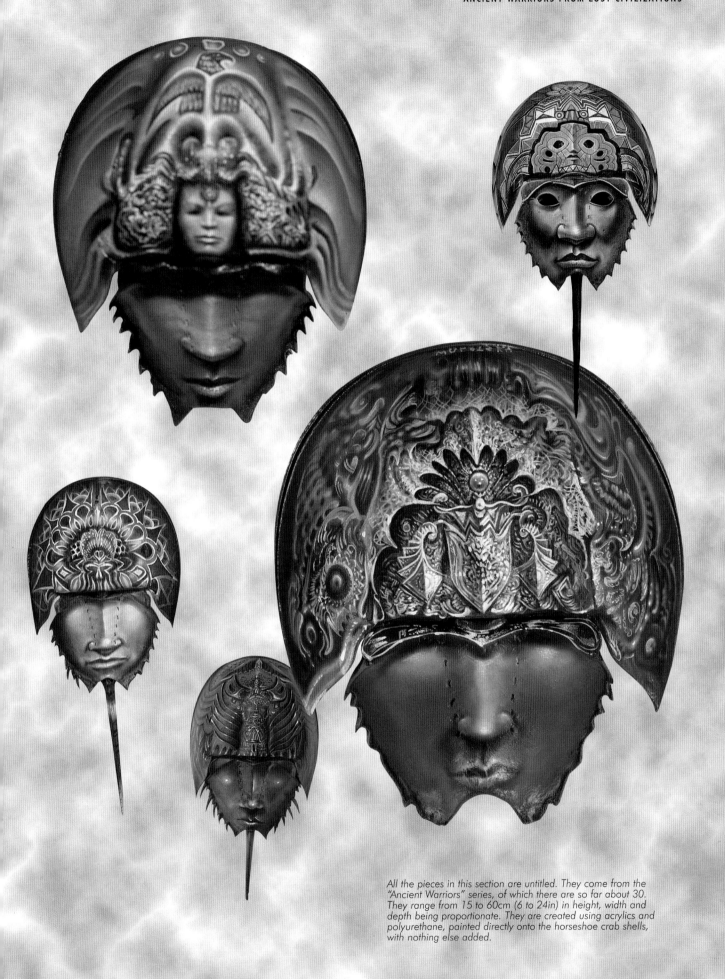

All the pieces in this section are untitled. They come from the "Ancient Warriors" series, of which there are so far about 30. They range from 15 to 60cm (6 to 24in) in height, width and depth being proportionate. They are created using acrylics and polyurethane, painted directly onto the horseshoe crab shells, with nothing else added.

SOME OF THAT TECHNICAL STUFF

Before I start a cover illustration I'm usually sent the manuscript to read. As I do this I make notes and/or thumbnail sketches. Even by the time I send them in to the art director my sketches are still pretty rough; I don't like to produce completely finished coloured comps because I want the painting itself to feel as fresh as possible. If you've planned everything too much in advance the final painting can come across as a bit stale.

I work mainly in acrylics, though sometimes in water-colours, and usually on illustration board, canvas or paper – OK, or even a horseshoe crab shell. I discovered as soon as I started doing illustration work that you often have to work right up to the deadline, which is why I've stayed away from oils ever since the early days of my career.

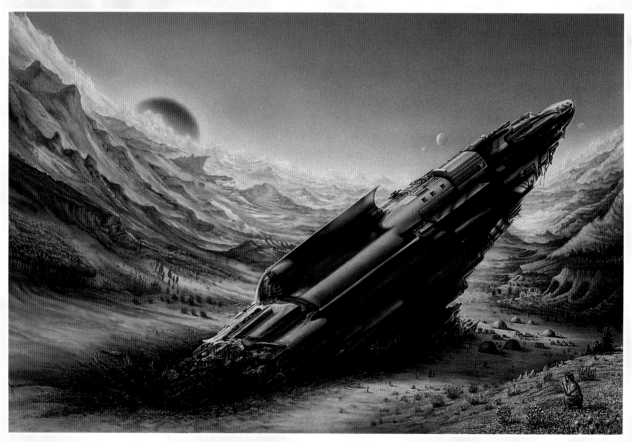

Darkover Landfall
cover for the novel by Marion Zimmer Bradley, Science Fiction Book Club, 1972
50 x 75cm (20 x 30in), acrylic on board

With acrylics I can keep on making subtle changes to the painting while I'm doing it, although still keeping the overall design the same so that I don't screw up the art directors' plans when they come to put in the type.

I work almost exclusively with brushes, plus some airbrush. In using the latter I rarely ever employ frisket, instead painting with a brush around the area I've sprayed. Then it's a question of building the painting up, putting on layers; sometimes it will have four or five layers on it before it's completed.

As for the order in which I complete the illustration, I don't stick to any single set formula. Sometimes I'll work up from the bottom. Sometimes I'll start in the middle.

Or maybe I'll start with the dark areas and then work through the middle tones until I get to the lightest. One of the final things I do is punch up the highlights, to make the painting sing.

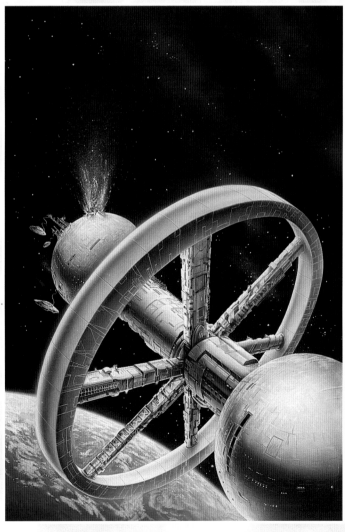

interior illustration for *Marion Zimmer Bradley's Fantasy magazine*
pen and ink

Fortress
cover for the novel by David Drake, Tor, 1987
50 x 75cm (20 x 30in), acrylic on board

Ron Walotsky: An Appreciation (No Haiku)

This is not a biography – I don't do stats. I don't think I could do stats in this case anyway, because enumerating Ron Walotsky's creative statistics would take up all the space I'm supposed to be using for an appreciation. It isn't that Ron is just prolific – his output verges on the Promethean.

Ron doesn't just do cards for game companies: he does entire decks. He doesn't just do book covers: he does whole series. Where other artists create individual paintings, Ron generates the work of a studio, producing by the handful, the gross, the bushel and the peck. The thing of it is, he's so casual about it that you tend not to recognize the achievement. It's like listening to a house painter describe how he's going to redo the interior of the Sears Tower. By himself. Next week. With suitable frescoes and flourishes and maybe a mural or two thrown in just for a little variety.

And the wonder, the miracle, the delight of it is that it is all good. Because Ron does not sacrifice quality for speed. There is nothing slapdash about the finished compositions he turns out for game companies, book publishers, private parties, singular commissions and cards.

Fast, oh yeah. Fast, and versatile. So versatile that I'll bet many of you have seen a couple of dozen Ron Walotsky paintings that you never thought of as being by Ron Walotsky. Because he does not limit himself. One thing you cannot say about Ron is what kind of

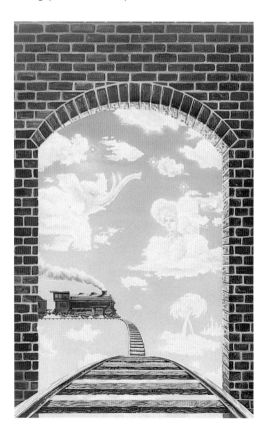

illustrator he is, a definition I apply in the most complimentary way.

Want hi-tech? Check out Ron's spaceships and future worlds. Want astronomical art? That's Ron's work over there on the wall, not Chesley Bonestell's or Ron Miller's or Rick Sternbach's. How about the characters of science fiction? Study the real expressions on the faces of the real people he paints.

High fantasy? Horror? Sword and Sorcery? How about a children's book? Horseshoe crabs?

Wait a minute.

Horseshoe crabs?

Did I mention that Ron somehow, probably in another space-time continuum he keeps tucked away in a spare drawer somewhere, manages to find time to paint for himself? And one of the things he paints is horseshoe crabs. In fact, I believe I can say unequivocally and without fear of contradiction that Ron Walotsky is the premier horseshoe crab painter working in the United States today.

When I say that Ron paints horseshoe crabs I do not mean that he supplies them with racing stripes, pin work and backward-streaming flames so that they can return to the sea and subsequently overawe their equally primitive but less aesthetically endowed companions. What Ron does with a horseshoe crab (deceased) is to transform it. Through the enchanted application of brush, paint, talent, imagination and the artist's eye (that's the third one, there, in the middle of the forehead) the lowly crab becomes a humanized figure of fantasy, a totem raised up and extracted from an unknown society, an emblem fraught with mystery and magic. One thing of beauty has, in Ron's hands, become another entirely. Through the gift of his art he has given a demised crustacean another life, another existence.

And he does this, of course, in his spare time.

Along with the pebbles.

Yes, Ron Walotsky paints pebbles. Resplendent, liquid, burnished, brightly coloured, enchanted pebbles. In Ron's house is my favourite piece of Walotsky art, a huge canvas consisting of nothing but painted pebbles as they might lie on a beach, or in the bed of a stream. It seems so simple, until you look long and hard at it and realize what has been accomplished. Any fool sketch-head can make a dramatic painting of Yosemite Valley, or crashing waves, or the twilight skyline of New York. But to grab a viewer's attention with pebbles, to engage their emotions with bits of paint that aspire to represent and interpret nothing more than tiny, water-polished rocks – that requires something more than skill, more than mere proficiency with charcoal and pencil and brush. It requires the ability to do Art, which is rather more than simply what is needed to illustrate.

So I present to you: Ron Walotsky, Artist. Go thou and admire. And remember that, when viewing Ron's work, small, secretive, private smiles of delight and pleasure are not only acceptable.

They are virtually *de rigueur.*

Alan Dean Foster

Covers by Ron Walotsky

This is a list of first printings only; it omits straightforward reprints and reissues.

Science Fiction and Fantasy Books

1967
Living Way Out, Wyman Guin, Avon

1968
An ABC of Science Fiction, Tom Boardman Jr (ed), Avon Books
Cryptozoic!, Brian W. Aldiss, Doubleday

1969
Black Flame, Stanley G. Weinbaum, Avon Books
Blue Star, Fletcher Pratt, Ballantine AdultFantasy
Dark Stars, Robert Silverberg (ed), Ballantine
Dimension Thirteen, Robert Silverberg, Ballantine
The Last Continent, Edmund Cooper, Dell
Lord of Light, Roger Zelazny, Avon Books
Tecnocracy, Robert Shirley, Ace
Up the Line, Robert Silverberg, Ballantine
Venus Plus X, Theodore Sturgeon, Pyramid

1970
Against the Fall of Night, Arthur C. Clarke, Pyramid
Confessions of a Warlock, Curtis Lavander, Lancer
Creatures of Light and Darkness, Roger Zelazny, Avon
The Dark Symphony, Dean R. Koontz, Lancer
The Downstairs Room, and Other Speculative Fiction, Kate Wilhelm, Dell
England Swings SF, Judith Merril (ed), Ace
The Magic of Atlantis, Lin Carter (ed), Lancer
The Sword Swallower, Ron Goulart, Dell
Transmigration, J.T. McIntosh, Avon Books
Understanding MU, Hans S. Santesson, Paperback Library
Worlds of Science Fiction, Robert P. Mills (ed), Paperback Library

1971
Children of the Griffin, Elizabeth Giles, LancerGothic
The Doomsday Exhibit, Paul W. Fairman, Lancer
Five-Odd, Groff Conklin (ed), Pyramid
The Shores Beneath, James Sallis (ed), Avon Books
Ten Million Years to Friday, John Lymington, Lancer
Voices from the Sky, Arthur C. Clarke, Pyramid

1972
Cloak of Aesir, John W. Campbell Jr, Lancer
Infinity Four, Robert Hoskins (ed), Lancer
Overlay, Barry N. Malzberg, Lancer
Strange Tomorrows, Robert Hoskins (ed), Lancer

1973
The Eternal Man, Louis Pauwels & Jacques Bergier, Avon Books
The Haunted Earth, Dean R. Koontz, Lancer
Infinity Five, Robert Hoskins (ed), Lancer
The Men Inside, Barry N. Malzberg, Lancer
Pig World, Charles W. Runyon, Lancer
Robots Have No Tails, Henry Kuttner, Lancer
The Unreal People, Martin Siegel, Lancer

1974
New Dimensions 2, Robert Silverberg (ed), Avon Books
Strange Ecstasies, Michael Parry (ed), Pinnacle
Tactics of Conquest, Barry N. Malzberg, Pyramid

1975
Options, Robert Sheckley, Pyramid

1976
The Guns of Avalon, Roger Zelazny, Avon Books
Sign of the Unicorn, Roger Zelazny, Avon Books

1977
Apocalypses, R.A. Lafferty, Pinnacle
Cluster, Piers Anthony, Avon Books
Doorways in the Sand, Roger Zelazny, Avon Books
The End of the Dream, Philip Wylie, DAW
The Hand of Oberon, Roger Zelazny, Avon Books
Last Transaction, Barry N. Malzberg, Pinnacle
Nine Princes in Amber, Roger Zelazny, Avon Books
The Realms of Tartarus, Brian Stableford, DAW

1978
Chaining the Lady, Piers Anthony, Avon Books
Chrome, George Nader, Putnam
Immortal: Short Novels of the Transhuman Future, Jack Dann (ed), Harper & Row
Kirlian Quest, Piers Anthony, Avon Books
The Man in the Maze, Robert Silverberg, Avon Books
Omnivore, Piers Anthony, Avon Books
Orn, Piers Anthony, Avon Books
Ox, Piers Anthony, Avon Books

1979
Catacomb Years, Michael Bishop, Berkley-Putnam
The Courts of Chaos, Roger Zelazny, Avon Books
Earth Ship and Star Song, Ethan L. Shedley, Viking
Titan, John Varley, Berkley-Putnam

1980
Cassilee, Susan Coon, Avon Books
Lord Valentine's Castle, Robert Silverberg, Harper & Row
Rahne, Susan Coon, Avon Books
Thousandstar, Piers Anthony, Avon Books

1981
Fireworks, Angela Carter, Harper & Row
Mute, Piers Anthony, Avon Books
Robert Silverberg Omnibus, Robert Silverberg, Harper & Row
Sons of Earth, Richard Rhodes, Coward McCann & Geoghegan
The Virgin, Susan Coon, Avon Books

1982
Blooded on Arachne, Michael Bishop, Arkham House
Chiy-une, Susan Coon, Avon Books
Conan the Defender, Robert Jordan, Tor, trade paperback
Conan the Invincible, Robert Jordan, Tor
Viscous Circle, Piers Anthony, Avon Books
Where Time Winds Blow, Robert P. Holdstock, Science Fiction Book Club

1983
Conan the Unconquered, Robert Jordan, Tor
Fires of Paratime, L.E. Modesitt Jr, Science Fiction Book Club
Millennium, John Varley, Science Fiction Book Club

1984
Annals of the Time Patrol, Poul Anderson, Science Fiction Book Club
Forty Thousand in Gehenna, C.J. Cherryh, Science Fiction Book Club
Master of Time and Space, Rudy Rucker, Bluejay
The Starcrossed, Ben Bova, Ace

1985
Dinner at Deviant's Palace, Tim Powers, Science Fiction Book Club
Ireta Adventure, Anne McCaffrey, Science Fiction Book Club
Limits, Larry Niven Science Fiction Book Club
Radio Free Albemuth, Philip K. Dick, Arbor
The Reluctant King, L. Sprague de Camp, Science Fiction Book Club
Schismatrix, Bruce Sterling, Arbor
Sudanna, Sudanna, Brian Herbert, Arbor

1986
A Door into Ocean, Joan Slonczewski, Arbor
Dorothea Dreams, Suzy McKee Charnas, Arbor
Ghost, Piers Anthony, Tor
Golem in the Gears, Piers Anthony, Science Fiction Book Club
The Man the Worlds Rejected, Gordon R. Dickson, Tor
1986 Annual World's Best SF, Donald A. Wollheim (ed), Science Fiction Book Club
The Prometheans, Ben Bova, Tor
Terry Carr's Best SF of the Year #15, Terry Carr (ed), Tor

1987
The AI War, Stephen Ames Berry, Tor
Architects of Hyperspace, Thomas R. McDonough, Avon Books
Beyond Heaven's River, Greg Bear, Tor
The Big Jump, Leigh Brackett, Tor
The Crown Jewels, Walter Jon Williams, Tor
Lear's Daughters, M. Bradley Kellogg, Science Fiction Book Club
Prisoners of Arionn, Brian Herbert, Arbor
Sea of Glass, Barry B. Longyear, St Martin's Press
Speaker to Heaven, Atanielle Annyn Noel, Arbor

1988
After Long Silence, Sheri S. Tepper, Science Fiction Book Club
Alien Light, Nancy Kress, Arbor/Morrow
Anti-Grav Unlimited, Duncan Long, Avon Books
Atheling, Grace Chetwin, Tor
Born with the Dead, Robert Silverberg, Tor
Burning Tears of Sassurum, Sharon Baker, Avon Books
Collision Course, Robert Silverberg, Tor
Denner's Wreck, Lawrence Watt-Evans, Avon Books
Destiny's End, Tim Sullivan, Avon Books
Drowning Towers, George Turner, Arbor/Morrow
Final Assault, Stephen Ames Berry, Tor
Heaven Cent, Piers Anthony, Science Fiction Book Club
The Queen of the Damned, Anne Rice, Ultramarine Press

Roads of Heaven, Melissa Scott, Science Fiction Book Club
Splendid Chaos, John Shirley, Franklin Watts
Vale of the Vole, Piers Anthony, Science Fiction Book Club

1989
Ancient Heavens, Robert E. Vardeman, Avon Books
Eye in the Sky, Philip K. Dick, Collier-Nucleus
Houston, Houston, Do You Read?, James Tiptree Jr, Tor
Non-Stop, Brian W. Aldiss, Science Fiction Book Club
Sugar Festival, Paul Park, Science Fiction Book Club
Talent for War, Jack McDevitt, Science Fiction Book Club

1990
The Barsoom Project, Larry Niven, Science Fiction Book Club
Cortez on Jupiter, Ernest Hogan, Tor
The Death of Doctor Island, Gene Wolfe, Tor
Hyperion Cantos, Dan Simmons, Science Fiction Book Club
Man from Mundania, Piers Anthony, Science Fiction Book Club
Redshift Rendezvous, John E. Stith, Science Fiction Book Club
Riding the Torch, Norman Spinrad, Tor

1991
Babel-17, Samuel R. Delaney, Easton Press
Griffin's Egg, Michael Swanwick, St Martin's Press
Nanoware Time, John Varley, Tor
The Persistence of Vision, Ian Watson, Tor
Xenocide, Orson Scott Card, Science Fiction Book Club

1992
Carrie, Stephen King, G.K. Hall
Eye in the Sky, Philip K. Dick, Macmillan
The Genocidal Healer, James White, Science Fiction Book Club
Sneeze on Sunday, Andre Norton, Tor
The Three Stigmata of Palmer Eldritch, Philip K. Dick, Science Fiction Book Club
Xenocide, Orson Scott Card, Science Fiction Book Club

1993
The Fourth Guardian, Ronald Anthony Cross, Tor
The Other Side of the Sun, Madeleine L'Engle, Thorndike Hall
Temporary Agency, Rachel Pollack, St Martin's Press

1994
The Eternal Guardian, Ronald Anthony Cross, Tor
2001: A Space Odyssey, Arthur C. Clarke, G.K. Hall

1995
Lake of the Long Sun, Gene Wolfe, Science Fiction Book Club
Primary Inversion, Catherine Asaro, Tor
War of the Worlds, H.G. Wells, G.K. Hall

1996
Ancient Echoes, Robert Holdstock, Penguin Roc
From the End of the Twentieth Century, John M. Ford, NESFA Press
Lest Darkness Fall, L. Sprague de Camp, Science Fiction Book Club
The Malacia Tapestry, Brian Aldiss, Easton Press
Nine Princes in Amber, Roger Zelazny, Easton Press
Panda Ray, Michael Kandel, St Martin's Press
Roynosseros, Terry Dowling, Science Fiction Book Club
The 37th Mandala, Marc Laidlaw, St Martin's Press
Unknown Regions, Robert Holdstock, Penguin Roc

1997
Donnerjack, Roger Zelazny and Jane Lindskold, Easton Press
Epiphany of the Long Sun, Gene Wolfe, Science Fiction Book Club
Gate of Ivory, Gate of Horn, Robert Holdstock, Penguin Roc
Lord Valentine's Castle, Robert Silverberg, Easton Press
Starplex, Robert Sawyer, Science Fiction Book Club
Tau Zero, Poul Anderson, Science Fiction Book Club

1998
The Crow: Shattered Lives, Broken Dreams, ed J. O'Barr and Ed Kramer, Ballantine
The Demon Princes, Jack Vance, Science Fiction Book Club
Hawks, Catherine Asaro, Tor
The Moon Maid, R. García y Robertson, Golden Gryphon Press

1999
Dragondrums, Anne McCaffrey, Thorndike Hall
Essential Saltes, Don Webb, St Martin's Press
Return to Mars, Ben Bova, Easton Press
Sign of the Unicorn, Roger Zelazny, G.K. Hall
Valentine of Majipoor, Robert Silverberg, Science
 Fiction Book Club
Water Witch, Connie Willis & Cynthia Felice,
 G.K. Hall

Other Book Covers

1979
Hawks, Joseph Amiel, Putnam,

1981
Red Dragon, Thomas Harris, Putnam

1983
Ambush, Donald Clayton Porter, G.K. Hall

1986
Fletch, Too, Gregory McDonald, Thorndike Press
Fletch Won, Gregory McDonald, Thorndike Press

1991
Today is Another Tomorrow, Missy D'Urberville,
 St Martin's Press

1992
Belgrave Square, Anne Perry, Thorndike Press
The Case of the Calendar Girl, Erle Stanley Gardner,
 Thorndike Press
Dear Family, Camilla Bittle, Thorndike Press
Driving Force, Dick Francis, Thorndike Press
Hot Property, Sherryl Woods, Thorndike Press
Hot Secrets, Sherryl Woods, Thorndike Press
Journey Back to Wuthering Heights, Lin Haire-Sargent,
 Thorndike Press
Mortal Stakes, Robert B. Parker, Thorndike Press
Perry Mason: The Case of the Borrowed Brunette, Erle
 Stanley Gardner, Thorndike Press
Promised Land, Robert B. Parker, Thorndike Press
The Right Kind of War, John McCormick, Thorndike
 Press

1993
Anne of Avonlea, L.M. Montgomery, Thorndike Press
Anne of Green Gables, L.M. Montgomery, Thorndike
 Press
The Case of the Sulky Girl, Erle Stanley Gardner,
 Thorndike Press
Dead Freight for Piute, Luke Short, Thorndike Press
Defend and Betray, Anne Perry, Thorndike Press
Demons, Bill Pronzini, Thorndike Press
Farrier's Lane, Anne Perry, Thorndike Press
Fiddler and McCan, Cameron Judd, G.K. Hall
The General's Daughter, Nelson DeMille, Thorndike
 Hall
Hard Winter at Broken Arrow Crossing, Steven Bly,
 Thorndike Hall
The Haunting of Lamb House, Joan Aiken, Thorndike
 Press
King Charlie's Riders, Max Brand, G.K. Hall
Kiss Me Deadly, Mickey Spillane, G.K. Hall
Long Storm, Ernest Haycox, Thorndike Press
The Lord Made Them All, James Herriot, G.K. Hall
Man from the Desert, Luke Short, Thorndike Press
Man-Size, William Macleod Raine, Thorndike Press
Moscow Twilight, William E. Holland, Thorndike Press
Night of the Hawk, Dale Brown, Thorndike Press
On the Dodge, William Macleod Raine, Thorndike
 Press
Paper Doll, Robert B. Parker, Thorndike Press
Ronicky Doone, Max Brand, G.K. Hall
The Silken Web, Sandra Brown, Thorndike Press
Son of Fletch, Gregory Mcdonald, Thorndike Press
Spring Came on Forever, Bess Streeter, Aldrich
 Press
Storm over the Lightning "L", Clifford Blair, Thorndike
 Press
Summer of Smoke, Luke Short, Thorndike Press
Sundown Slim, Ernest Haycox, Thorndike Press
Thunder Valley, Lauren Paine, Thorndike Press
Tiger Butte, Jack Cummings, Thorndike Press
The Trap at Comanche Bend, Max Brand, Thorndike
 Press
Unnatural Causes, P.D. James, G.K. Hall
Without Remorse, Tom Clancy, Thorndike Press

1994
Arizona Star, Faith Baldwin, Thorndike Press
Blue Moon, Luanne Rice, Thorndike Press
Body of Evidence, Patricia Cornwell, G.K. Hall
The Counterfeit Gentleman, Charlotte Louise Dolan,
 G.K. Hall
Dead Eyes, Stuart Woods, Thorndike Press
Fatal Lady, Rae Foley, Thorndike Press
Forfeit, Dick Francis, G.K. Hall
Grave Music, Cynthia Harrod-Eagles, G.K. Hall

Hot Schemes, Sherryl Woods, G.K. Hall
The Hyde Park Headsman, Anne Perry, Thorndike
 Press
In the Frame, Dick Francis, G.K. Hall
The Leper Ship, Peter Tonkin, Thorndike Press
The Lively Lady, Kenneth Roberts, G.K. Hall
Miami It's Murder, Edna Buchanan, Thorndike Press
Night Shift, Stephen King, G.K. Hall,
Pacific Destiny, Dana Fuller Ross, G.K. Hall
Playing for the Ashes, Elizabeth George,
 Thorndike Press
Postmortem, Patricia Cornwell, G.K. Hall
Prizzi's Money, Richard Condon, Thorndike Press
Risk, Dick Francis, Thorndike Press
Seven for a Secret, Victoria Holt, G.K. Hall
Sleeping Beauties, Susanna Moore, Thorndike Press
Tender is the Night, F. Scott Fitzgerald, G.K. Hall
Texas Sunrise, Fern Michaels, Thorndike Press
To Kill the Leopard, Theodore Taylor, Thorndike Press
The Twisted Thing, Mickey Spillane, G.K. Hall
With an Extreme Burning, Bill Pronzini,
 Carroll & Graf

1995
Around the World with Auntie Mame, Patrick Dennis,
 G.K. Hall
Cat in a Crimson Haze, Carole Nelson Douglas,
 Thorndike Press
Fare Play, Barbara Paul, G.K. Hall
Glorious Morning, Julie Ellis, Thorndike Press
Hot Money, Sherryl Woods, G.K. Hall
The Killing Floor, Peter Turnbull, G.K. Hall
The Robe, Lloyd C. Douglas, G.K. Hall
The Shadow Man, John Katzenbach, G.K. Hall
The Summons, Peter Lovesey, Thorndike Press
Total Eclipse, Liz Rigbey, G.K. Hall
Traitors' Gate, Anne Perry, Thorndike Press
Wild Sweet Wilderness, Dorothy Garlock,
 Thorndike Press

1996
Barron Land Showdown, Luke Short, Thorndike Press
Maison Jennie, Julie Ellis, Thorndike Press
Red Eye, Clyde Edgerton, Thorndike Press

Covers for *The Magazine of Fantasy & Science Fiction*

1967
May: "Planetoid Idiot", Phyllis Gottlieb
August: "Reduction in Arms", Tom Purdom

1968
February: "Stranger in the House", Kate Wilhelm
June: "The Consciousness Machine", Josephine
 Saxton
October, "The Fangs of the Trees", Robert Silverberg

1969
March: "Calliope and Charkin and the Yankee
 Doodle Thing", Evelyn E. Smith
October: 20th anniversary cover

1970
March: "The Fatal Fulfillment", Poul Anderson
July: "Making Titan", Barry N. Malzberg

1971
May: "The Bear with the Knot in his Tail", Steven Tall
July: "Jack of Shadows", Roger Zelazny
August: "Jack of Shadows", (cont'd), Roger Zelazny

1972
January: "McGallagher's Brat", Ray Bradbury
June: "Sun of the Morning", Phyllis Gotlieb
July: "The Brave Free Men", Ray Bradbury
December: "Dr. Dominoe's Dancing Doll",
 Hal R. Moore

1973
November: "Closed Sicilian", Barry N. Malzberg
December: "Not a Red Cent", Robin Scott Wilson

1974
March: "The Star of Stars", Robert F. Young
July: "A Father's Tail", Sterling E. Lanier
December: "Venus on the Half-Shell", Kilgore Trout

1976
February: "The Samurai and the Willows", Michael
 Bishop
December: "The Ghost of a Crown", Sterling E. Lanier

1977
January: "The Pale Brown Thing", Fritz Leiber
December: "Assassins", Ron Goulart

1978
July: "The Syndicated Time", Sterling E. Lanier

1979
January: "Palely Loitering", Christopher Priest
September: "The Extraordinary Voyages of Amelée
 Bertrand", Joanna Russ
November: "Lord Valentine's Castle", Robert
 Silverberg

1980
December: "The Autopsy", Michael Shea

1981
February: "Menage Outre", Lee Killough
May: "The Thermals of August", Ed Bryant
December: "The Tehama", Bob Leman

1982
June: "The Devil of Malkirk", Charles Sheffield

1983
February: "Grunt-12 Test Drive", Michael Shea

1984
February: "With a Little Help from her Friends",
 Michael Bishop
October: "Somebody Else's Magic", Marion Zimmer
 Bradley
November: "The Doors", Barbara Owens

1985
December: "A Spanish Lesson", Lucius Shepard

1986
April: "Midnight Smack", Vanca Aandahl
July: "The Wisdom of Having Money", O. Niemand

1987
February: "Saving Time", Russell Griffin

1988
September: "The Son of Walks thru Fire",
 P. E. Cunningham

1990
February: "The Cold Cage", Ray Aldridge
July: "Dr. Pak's Pre-School", David Brin

1991
April: "Gate of Faces", Ray Aldridge

1992
March: "Tree of Life, Book of Death", Grania Davis
October: "Bridges", Charles De Lint

1994
February: "Busy Dying", Brian Stableford

1995
June: "The Spine Divers", Ray Aldridge

1996
October: "Candle in a Bottle", Carolyn Alves Gilman

1998
January: "Reading the Bones", Sheila Finch
December: "The Isle in the Lake", Phyllis Eisenstein

1999
April: "The Hestwood", Rob Chilson

Other Magazine Covers

1977
September: *Scholastic Voice*

1978
October: *Heavy Metal*

1980
February: *Heavy Metal*

1991
November: *Amazing Stories*

1993
Summer: *Marion Zimmer Bradley's Fantasy Magazine*

1998
February: *Analog*

1999
January: *Analog*